IMAGES
*of America*

# COLORADO IN
# THE CIVIL WAR

ON THE COVER: COLORADO VOLUNTEERS, EMPIRE CITY, COLORADO. In the only photograph of Colorado troops under arms drilling, the men of 1st Colorado Volunteer Infantry, Company G, pose by a flagpole in Empire City in the summer of 1861. Capt. Josiah Hambleton was their commander. The men are armed with military weapons with fixed bayonets, held at the support arms position. The musicians include a fifer, snare drummer, and bass drummer. At this point, the Colorado troops had not received any real uniforms, and the men are dressed in a variety of civilian hats and clothing, including top hats. Some of the buildings in this 1861 photograph still stand in Empire. (Courtesy of Denver Public Library, Western History Collection X-8187.)

IMAGES
*of America*

# COLORADO IN
# THE CIVIL WAR

John Steinle

ARCADIA
PUBLISHING

Published by Arcadia Publishing
Charleston, South Carolina

Printed in the United States of America

Library of Congress Control Number: 2022951720

For all general information, please contact Arcadia Publishing:
Telephone 843-853-2070
Fax 843-853-0044
E-mail sales@arcadiapublishing.com
For customer service and orders:
Toll-Free 1-888-313-2665

Visit us on the Internet at www.arcadiapublishing.com

*This book is dedicated to Bob Moulder—friend, mentor,
and guardian of our Civil War history.*

# CONTENTS

# ACKNOWLEDGMENTS

The author and publisher acknowledge that this book encompasses traditional territories and ancestral homelands of the Cheyenne, Arapaho, Ute, Apache, Comanche, Kiowa, Lakota, Pueblo, and Shoshone Nations. Further, we acknowledge the 48 contemporary tribal nations historically tied to the land now called Colorado.

Bob Moulder, Bill Elswick, and Rob Barnes have all shared wisdom, advice, and expertise. J.J. Rutherford guided me to expert consultations about the Sand Creek Massacre.

Those who have helped assemble a pictorial record of the Colorado Volunteers include, from History Colorado, Jori Johnson, collections access coordinator; Tamar McKee, manager, Stephen H. Hart Research Center; Cody Robinson, research service assistant; Aaron Marcus, Gill Foundation associate curator of LBGTQ history; Viviana Guajardo, digital imaging assistant; David Anderson, digital imaging contractor; Chris Juergens, Anschutz associate curator of military history; Sam Bock, historian, exhibit developer, managing editor; and Eric Carpio, chief community museum officer and director of Fort Garland Museum & Cultural Center at History Colorado.

From the National Park Service, thanks go to George Elmore, chief ranger, Fort Larned National Historic Site; Brian Deaton, GIS specialist, National Park Service-National Trails; Carole Wenkler, acting superintendent, National Park Service National Trails; Jake Koch, park ranger, Bent's Old Fort National Historic Site; Teri Jobe, acting lead interpretive ranger, Sand Creek Massacre National Historic Site; and Rhonda Brewer, museum curator, Pecos National Historic Park–Fort Union National Monument.

I also received vital assistance from the following people: Terry Hydari, operations manager, DeGolyer Library, Southern Methodist University; Rachel Vagts, special collections and digital archives manager, Denver Public Library; Susan Chandler, library director, Nesbitt Memorial Library; Heather J. Potter, curator of photographs, and Emma Johansen, collections assistant, the Filson Historical Society; Catie Carl, digital imaging archivist, Palace of the Governors Photo Archives, New Mexico History Museum; Lisa Keys, Kansas Historical Society, State Archives Division; Lauren Miller, head of reference, Kansas Historical Society; Brittany Rodriguez, archivist and special collections librarian, Victoria Regional History Center; Claudia Rivers, head of special collections, University of Texas El Paso; Jeff Patrick, National Park Service librarian, Wilson's Creek National Battlefield; Vanya Scott, curatorial assistant, Golden History Museum & Park; Martin Knife Chief, Lakota, who gave me valuable advice from an Indigenous perspective; and Karen Meyer, bibliophile and proofreader, who rescued me from misspellings, grammatical errors, and clumsy phrasings.

# INTRODUCTION

A prominent Civil War website currently states, "Colorado played virtually no role in the Civil War." Like much internet "history," this statement is grotesquely false.

During the American Civil War of 1861–1865, Colorado Territory fielded three full Federal volunteer regiments, plus an independent battery of artillery, a Denver City Home Guard unit, a mounted militia regiment, several independent infantry and artillery companies, and numerous civilian support personnel. The Coloradans served not just in their home territory, but throughout the Western states and territories, including New Mexico, Kansas, Missouri, Arkansas, Utah, Wyoming, Texas, and the Indian Territory (Oklahoma).

At least 5,000 Coloradans served in Federal units fighting for the Union. Considering that the 1860 census showed only about 31,000 "White and Free Colored" people in Colorado Territory, this was one of the largest per capita Civil War service records of any state or territory.

Colorado troops played a dominant role in preventing the Confederacy from gaining control of the entire American Southwest during the New Mexico campaign in 1862. They fought in the largest battles of the Civil War west of the Mississippi River, helping to defeat the massive Confederate invasion of Missouri in 1864. In the Indian Territory, the Coloradans served alongside Native American Federal troops and the very first African American military unit to see combat in the Civil War. Hispanic volunteers from New Mexico and Colorado were also among their comrades.

Besides the Colorado citizens who served, units from New York, Kansas, Ohio, Missouri, Iowa, and New Mexico were stationed within Colorado Territory during the Civil War. They were joined by several units of "Galvanized Yankees," former Confederate prisoners who volunteered to join the Federal army rather than rot in prison camps. At least eight military forts were constructed and garrisoned in Colorado Territory just before or during the Civil War. Some of them, such as Fort Morgan, Fort Collins, Fort Garland, and Fort Lyon, formed the foundations for present-day communities.

Gold and silver from Colorado mines contributed millions to support the Northern economy and by extension the Federal war effort. Politically, the creation of Colorado, Nevada, and Dakota Territories in early 1861 gave the Federal government the means to establish territorial governments and recruit volunteers, assuring that the West would remain under Federal control.

By late 1862, Colorado had contributed three volunteer infantry units: the 1st Colorado, commanded by Col. John M. Chivington; the 2nd Colorado, led by Col. Jesse H. Leavenworth; and the 3rd Colorado, with James H. Ford as its colonel. The following year, the Colorado units were officially converted from infantry to cavalry, increasing their mobility traversing the vast distances of the West. The 1st Colorado Volunteer Infantry became the 1st Colorado Volunteer Cavalry, still commanded by Col. John Chivington. The 2nd and 3rd Colorado Volunteer Infantry were combined into the 2nd Colorado Volunteer Cavalry, commanded by Col. James Ford. Col. Jesse Leavenworth was dishonorably discharged for unauthorized recruiting of an artillery battery, an unjust decision that was later reversed.

Agriculture and the cattle industry in Colorado Territory grew during the Civil War years, expanding the economy beyond the stalled mining industry. The Platte and Arkansas River valleys filled up with ranches and farms. But this expansion was at the expense of Colorado's indigenous people, who were racked by hunger and disease and increasingly hemmed in by the new trails, growing Gold Rush communities, ranches, and farms. The buffalo were decreasing in number, and logging denuded the landscape of trees.

As ranches, farms, and new stagecoach routes spread out beyond the original gold mining communities, conflicts over lost or stolen cattle led to violence. Cheyenne chief Lean Bear was shot and killed by Colorado troops. In response, tribal raids against isolated ranches, stagecoach stops, and wagon trains in 1864 stranded Denver and other Colorado communities.

In reaction to the raids, many "settler forts" were built throughout Colorado to protect local ranching and farming families from tribal attacks in 1864–1865. Sometimes they were just fortified individual houses or stagecoach stops. These included Fort Wicked, also known as Godfrey's Ranche, near present-day Merino, Colorado. Valley Station, a stagecoach stop along the Overland Trail to Denver along the South Platte River near today's Sterling, Colorado, also withstood multiple raids. Territorial governor John Evans, who replaced William Gilpin in 1862, received permission from the US War Department to recruit an additional unit, the 3rd Colorado Volunteer Cavalry, for 100 days' duty only. Evans was convinced that these men had to act to justify their regiment's existence.

The result was that Colorado volunteers, led by Col. John M. Chivington, perpetrated one of the worst massacres of Native Americans in American history along Sand Creek, Colorado, in November 1864. Cheyenne and Arapaho villages were overrun by the troops. They slaughtered some 230 Cheyenne people, mostly women and children, scalping and mutilating many of the bodies. In stark contrast, some Colorado officers and troops present refused to shoot or participate in the desecration of the bodies. This atrocity sparked an even larger conflict, uniting the Plains tribes in a war that continued in stages long after the Civil War itself ended.

When details of the attack at Sand Creek leaked out, a Congressional investigation condemned Chivington's actions. A military inquiry in Denver brought out more details of the atrocities. Chivington's officer commission expired before he could be court-martialed, and Capt. Silas Soule, who had testified against Chivington, was murdered on the streets of Denver. Instead of quelling hostilities, the Sand Creek Massacre led to a magnified war with the tribes. In January and February 1865, the town of Julesburg along the Overland Trail was attacked twice and burned by a huge war party. Warfare in Colorado did not end with the Confederate surrender in 1865, but continued into 1868 and 1869 with the battles of Beecher's Island and Summit Springs.

The legacy of the Civil War remains strong in Colorado. Those who led the territory during the war became its postwar leadership cadre as well. They were instrumental in founding Colorado's enduring institutions of finance, transportation, and higher learning and in creating its economic and social structure. The unpleasant aspects of the war years—the Sand Creek Massacre, the summary execution of Confederate guerrillas without trial—were drowned under a sea of accolades for the men who had saved the Union.

Rather than an isolated conflict raging between 1861 and 1865, the Civil War was only one episode in a multifaceted military, economic, racial, and cultural struggle over control of the vast natural resources of the West with its deposits of precious metals, immense forests, boundless rivers, and millions of acres of arable land. Domination over vital transportation routes such as the Santa Fe Trail and Oregon Trail and the future track of the transcontinental railroad played a key role in the struggle. Seen in this light, the Civil War in the West and Colorado's part in it earn their true significance in the overall perspective of American history.

# One

# THE STAGE IS SET

A group of 13 men prospecting along the Front Range of the Rockies in 1858 panned a few hundred dollars' worth of gold out of local creeks. This discovery sparked the mass migration known as the Great Colorado Gold Rush. Soon, tens of thousands were struggling across the Great Plains to the "Pike's Peak Country." Communities sprang up as if by magic, including Denver City, Boulder City, Colorado City, Central City, and Georgetown. Coloradans created an extralegal interim government known as the "Territory of Jefferson."

Many early gold strikes were made by experienced Southern prospectors. They were later outnumbered by Northerners, including abolitionists who had fought in the "Bleeding Kansas" conflict between pro- and anti-slavery advocates. With the impending secession crisis over slavery looming, the stage was set for a bitter confrontation among the new arrivals. Republican Abraham Lincoln's election as president in November 1860 triggered this fateful moment since Lincoln was regarded as being anti-slavery.

As the Southern states seceded and formed the Confederate States of America, Coloradans were forced to choose sides. To assert Federal control, Congress officially created a new Colorado Territory in February 1861 and William Gilpin was appointed territorial governor. Then, in April, Confederate forces fired on Fort Sumter in Charleston Harbor, and the Civil War commenced.

When Gilpin arrived in Colorado in May 1861, he feared that Federal control of the territory was in dire peril since so many citizens were Southerners. Gilpin organized a Denver City Home Guard and two independent companies. Then he began the expensive process of recruiting and equipping a full Federal regiment, the 1st Colorado Volunteer Infantry, and building a large military base known as Camp Weld. The 1st Colorado men were nicknamed "Gilpin's Pet Lambs." Gilpin financed these efforts by issuing "sight drafts," promissory notes payable by the US Treasury. This would later cause Gilpin's dismissal, but he felt that the national emergency justified his actions in mobilizing Colorado Territory for the Union.

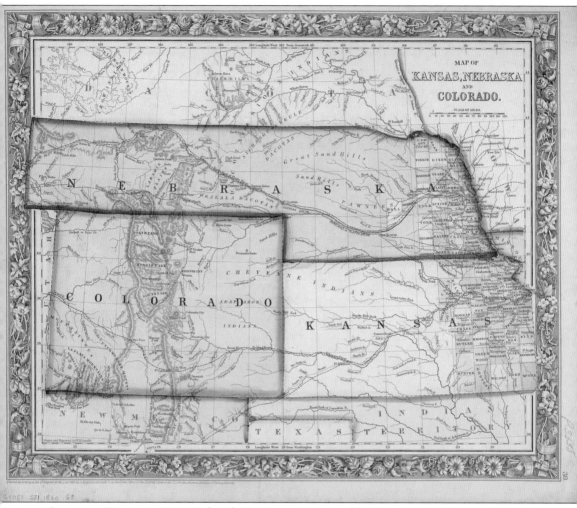

**COLORADO TERRITORY MAP.** Colorado Territory was created by Congress in February 1861. The territory was bracketed by the Oregon Trail to the north and the Santa Fe Trail to the south. The Cherokee Trail and Trappers' Trail led along the Rocky Mountain front range. Soon the Overland Trail and Smoky Hill Trail were established, funneling an ever-growing swarm of gold-seekers to the new territory. (Courtesy of History Colorado G4051.331.1860.G3.)

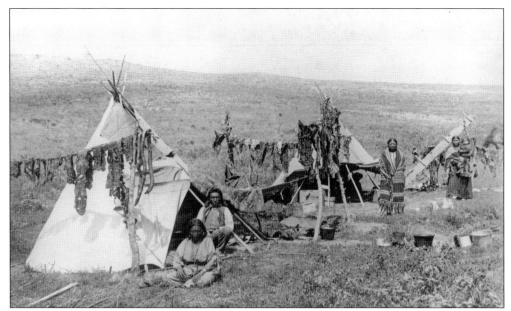

LAKOTA (SIOUX) CAMP, NORTHERN COLORADO. Lakota camps, and those of other tribes, were commonplace throughout Colorado during the 1860s. Ute, Cheyenne, Arapaho, Kiowa, Comanche, and Prairie Apache people were being pressured into ever-smaller areas as trail travelers and gold mining communities consumed many of their traditional resources. (Courtesy of History Colorado Scan No. 10039389.)

LITTLE RAVEN, ARAPAHO CHIEF. Little Raven, or Chief Hosa, was an important Arapaho "peace chief." He urged peace even during the tribal warfare of 1864 in Colorado Territory and after the Sand Creek Massacre. A signer of the 1861 Fort Wise Treaty, he also signed the 1867 Medicine Lodge Treaty confining the Southern Arapaho to a reservation in Oklahoma. (Courtesy of Denver Public Library Western History Collection X-32423.)

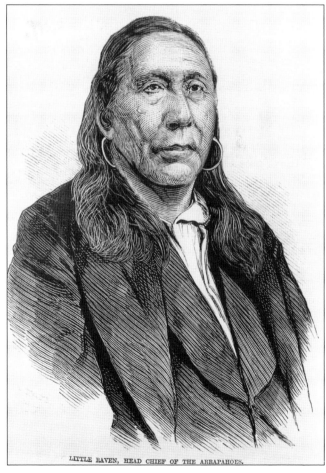

LITTLE RAVEN, HEAD CHIEF OF THE ARRAPAHOES.

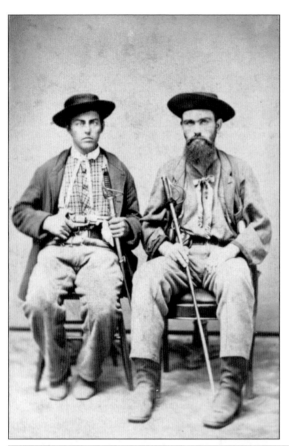

**BLEEDING KANSAS CONFLICT.** The Kansas-Nebraska Act of 1854 introduced "popular sovereignty," whereby territorial voters would decide if slavery should be allowed or banned. This led to a long-lasting guerrilla war between pro- and anti-slavery men, dubbed "border ruffians" like the men in this photograph. Abolitionists who had opposed slavery in Kansas later migrated to Colorado during the Gold Rush, enlisting in Colorado volunteer units. (Courtesy of Library of Congress.)

**SAN LUIS VALLEY, SOUTHWESTERN COLORADO.** Hispanic ranchers and farmers moved north from New Mexico into the San Luis Valley, where San Luis, Colorado's oldest Euro-American community, was established in 1851. Hispanic traditions remain strong in the San Luis Valley. The Capilla Viejo de San Acacio in San Luis, built in the late 1860s, is probably the oldest Euro-American place of worship in Colorado. (Courtesy of Jeffrey Beall.)

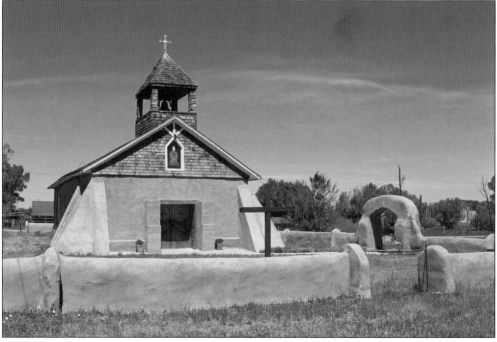

WILLIAM GREENEBERRY RUSSELL, PROSPECTOR. The Colorado Gold Rush was sparked by 13 men led by William Greeneberry "Green" Russell and his brothers Oliver and Levi. In July 1858, they panned a small amount of gold out of Little Dry Creek and Cherry Creek along Colorado's Front Range. Exaggerated by rumor, this gold strike led possibly 50,000 people to Colorado in 1858–1859. (Courtesy of History Colorado 86.70.124.)

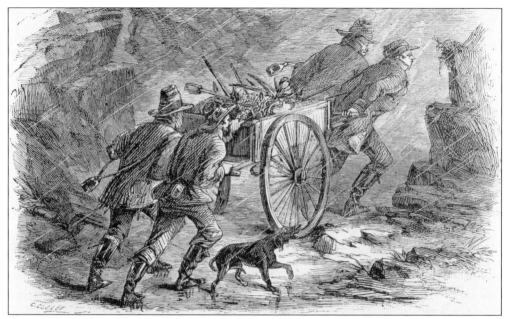

COLORADO GOLD RUSH, 1858–1860. Thousands of people devastated by the financial panic of 1857 struggled across the Great Plains to find riches. Half of them gave up before arriving or "saw the elephant" after failing to find gold, gave up, and returned home. Men drawn to Colorado during the Gold Rush were the raw material for Colorado's Federal volunteer regiments. (Courtesy of History Colorado-PH. PROP. 5379.)

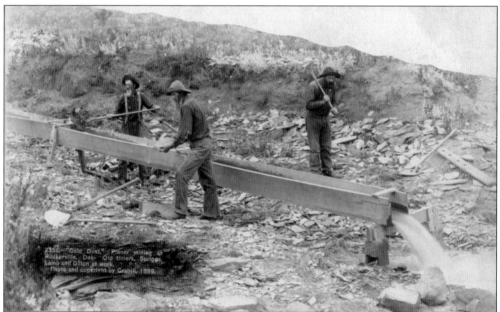

PROSPECTING IN THE COLORADO MOUNTAINS. During the Colorado Gold Rush of 1858–1860, prospectors used small pans to wash gold specks and nuggets from river or creek gravel. They progressed to using wooden sluices called "Long Toms." Shoveling gravel into the sluice, and running water through it, would trap the heavier gold in the "riffles," or slats built into the box, as the gravel washed through. (Courtesy of Library of Congress.)

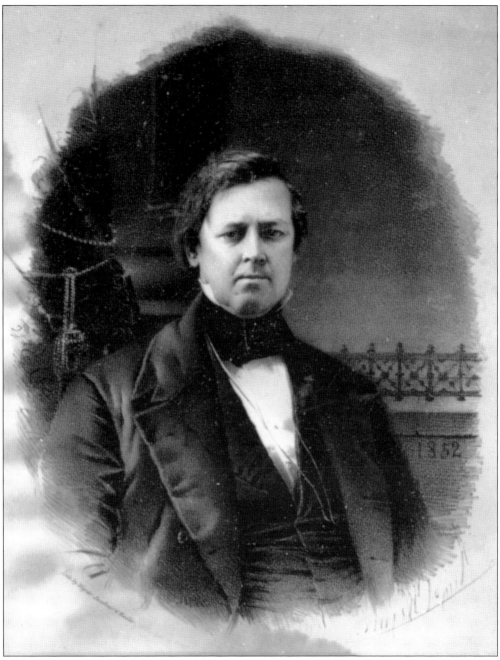

GEN. WILLIAM LARIMER, FOUNDER OF DENVER. William Larimer ran a freighting company when news of the Colorado Gold Rush reached him in Leavenworth, Kansas. Larimer recruited the "Leavenworth Party" and, along with other Kansas groups, arrived at Cherry Creek in November 1858. Larimer founded Auraria and took over St. Charles across Cherry Creek. He renamed it Denver City, honoring the Kansas territorial governor James Denver. (Courtesy of History Colorado 89.451.336.)

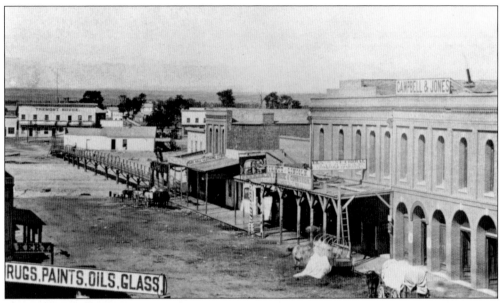

BLAKE STREET, DENVER CITY, EARLY 1860s.
Denver City grew from two small communities, St. Charles and Auraria, founded in 1858. By the 1860s, Denver City was established as a main communications, travel, and supply center in Colorado Territory. It also became the focus of military mobilization during the Civil War. This 1860s photograph shows the leading hotel in Denver, the Tremont House. (Courtesy of History Colorado 89.451.1120.)

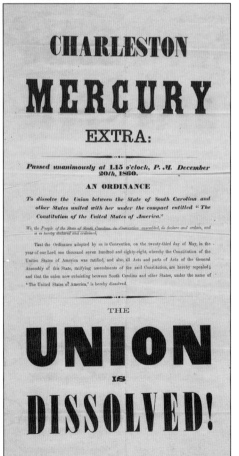

SECESSION BROADSIDE, SOUTH CAROLINA.
The *Charleston Mercury* announced South Carolina's secession from the Union with this broadside, printed on December 20, 1860. South Carolina was the first state to secede, and this announcement led eight other states to follow. The secession crisis would reach even the American West, envelope Colorado, tear friends and families apart, and lead to bloodshed and massacre. (Courtesy of Heritage Auctions.)

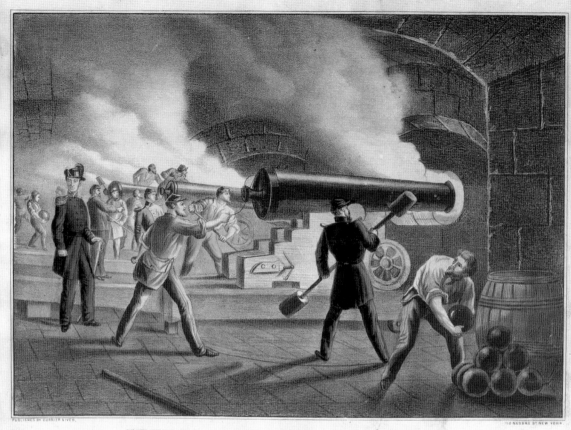

**FORT SUMTER, APRIL 12, 1861.** Fort Sumter, in Charleston Harbor, South Carolina, became the target of international attention after Confederate forces demanded its capitulation. The Lincoln administration rejected abject surrender. Prolonged negotiations and fruitless attempts to resupply or relieve the fort failed. On April 12, 1861, Confederate cannon opened fire at the fort, igniting the American Civil War. (Courtesy of Library of Congress.)

**WILLIAM GILPIN, COLORADO TERRITORIAL GOVERNOR.** William Gilpin lived an incredibly adventurous life, much of it in the West. After his appointment as Colorado's territorial governor, Gilpin worked tirelessly to preserve Colorado for the Union. His use of "sight drafts" to fund military preparedness backfired when the Lincoln administration hesitated to honor them. Gilpin was removed from office but remained a major booster of Western development. (Courtesy of History Colorado 89.541.893.)

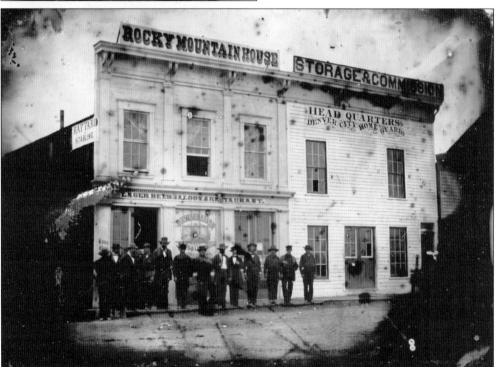

**DENVER CITY HOME GUARD, 1861.** In the fall of 1861, Colorado territorial governor William Gilpin recruited about two hundred men into a two-company unit known as the Denver City Home Guard. They provided security for Denver and Camp Weld. These men were mustered into Federal service and were discharged in May 1862, after Confederate influence in Colorado had been suppressed. (Courtesy of Denver Public Library, Western History Collection Z-3948.)

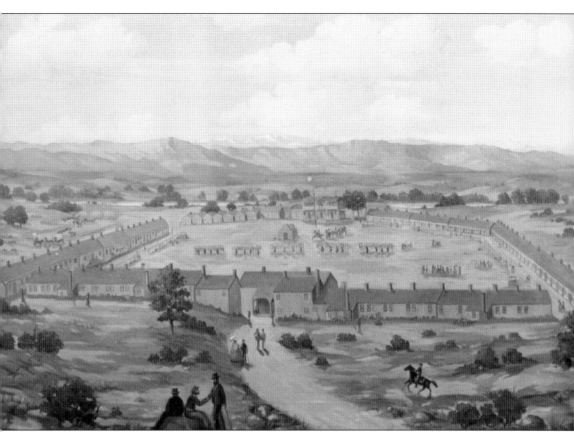

**CAMP WELD, FEDERAL ARMY BASE.** Construction on Camp Weld, about two miles south of Denver City, began in the fall of 1861, providing a recruiting, training, and supply center for Colorado volunteers. It was named after territorial secretary Lewis Weld. By November, the camp was finished, enclosing barracks, a hospital, and officers' quarters. The post was abandoned in 1865, and only a dilapidated marker shows its location today. (Courtesy of History Colorado 89.451.2953.)

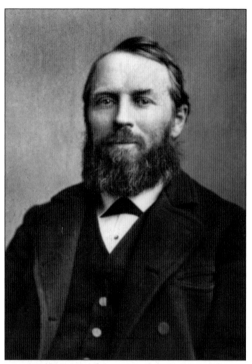

**WILLIAM BYERS, NEWSPAPER EDITOR.** After a successful career in Nebraska as a territorial legislator and founder of Omaha, William Byers followed gold rush fever to Colorado in 1859. In Denver, he founded one of Colorado's earliest newspapers, the *Rocky Mountain News*. Byers was a tireless booster of Colorado's development, a staunch supporter of Colorado's volunteers, and an apologist for the Sand Creek Massacre. (Courtesy of History Colorado 89.451.342.)

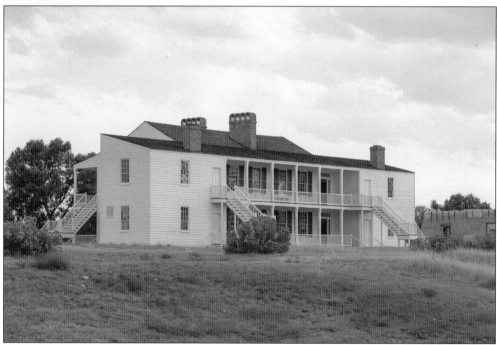

**HEADQUARTERS BUILDING, "OLD BEDLAM," FORT LARAMIE.** Fort Laramie, Wyoming Territory, was one of the major Federal military posts in the West. When the 1st Colorado Volunteer Infantry was formed, a wagon train of supplies from Fort Laramie arrived in Denver with 2,000 rifles, several 12-pound mountain howitzers, and ammunition. This allowed the unit to begin drill and target practice. (Courtesy of Library of Congress.)

**THEODORE DODD, DODD'S INDEPENDENT COMPANY.** In August 1861, burly Theodore Dodd enlisted as first lieutenant in an independent company commanded by Capt. Cornelius Hendren. Hendren's men journeyed to Fort Garland in preparation for action in New Mexico. Hendren was dismissed for drunkenness, and Dodd was elected captain. Then the company, now Company A of the 2nd Colorado Volunteer Infantry, marched to Fort Craig in southern New Mexico. (Private collection.)

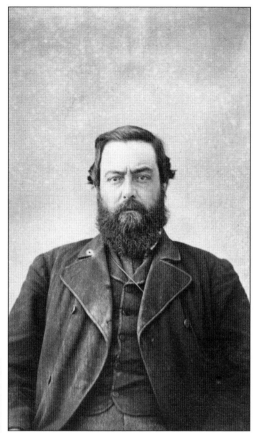

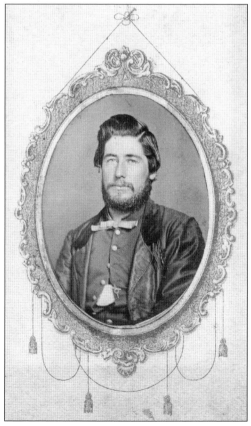

**JAMES H. FORD, FORD'S INDEPENDENT COMPANY.** Tall, lanky James Hobart Ford migrated from Nebraska to Colorado during the Gold Rush. Appointed commander of an independent infantry company, Ford led his men to Fort Garland for equipment and drill. Ford's company became Company B of the 2nd Colorado Volunteer Infantry, and was ordered to Fort Union, New Mexico, to defend that vital post from Confederate attack. (Private collection.)

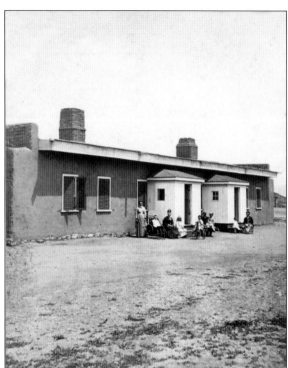

**FORT GARLAND, SAN LUIS VALLEY.** Fort Garland was built in 1858 to protect the local population from Ute raids, anchoring Federal control of the San Luis Valley. Early in the Civil War, the fort was an organizational and supply base for Ford's and Dodd's Independent Companies. Fort Garland was decommissioned in 1883. It survives as Colorado's only intact Civil War–era fort, owned and managed by History Colorado. (Courtesy of Library of Congress.)

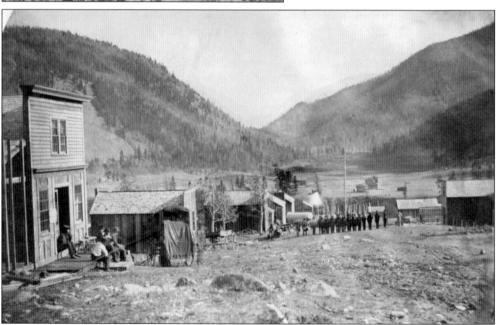

**COLORADO VOLUNTEERS, EMPIRE, COLORADO.** In the only photograph of Colorado troops under arms drilling, the men of 1st Colorado Volunteer Infantry, Company G, pose by a flagpole in Empire City, Colorado, in the summer of 1861. Capt. Josiah Hambleton was their commander. The men are armed with military weapons with fixed bayonets, and the musicians include a fifer, snare drummer, and bass drummer. (Courtesy of Denver Public Library, Western History Collection X-8187.)

# *Two*

# FIRST BLOOD

As Governor Gilpin mobilized Colorado Territory to support the Union, former US Army officer Henry Hopkins Sibley was assembling a brigade of three mounted Confederate regiments, complete with artillery, in Texas. The unit was dubbed the Sibley Brigade. With these 3,000 men, Sibley planned to conquer New Mexico and Colorado, then march to the California coast, capturing the Pacific ports. Such a campaign had succeeded during the war with Mexico under Gen. Stephen Watts Kearney.

Governor Gilpin responded by ordering the two independent Colorado companies to Fort Garland to receive weapons and equipment. Dodd's Company was then sent to Fort Craig, in southern New Mexico, and Ford's Company marched to Fort Union, north of Santa Fe.

The Sibley Brigade, moving north from Texas into New Mexico along the Rio Grande, reached the vicinity of Fort Craig in mid-February 1862. At the fort, the Federal commander, Col. Edward S. Canby, assembled about 3,800 men including companies from five US Army regular regiments, parts of five New Mexico volunteer regiments, McRae's six-gun artillery battery, and Dodd's Coloradans. The 1st New Mexico Volunteer Infantry commander was frontier legend Christopher "Kit" Carson.

On February 21, the two armies clashed along the Rio Grande near the abandoned village of Valverde north of Fort Craig. As the battle seesawed back and forth, 70 lancers from the 5th Texas Mounted Rifles charged Dodd's company. The Coloradans waited until the Texans were about 40 yards away, then fired a devastating volley that emptied most of the Texans' saddles. Though the battle had gone well along the Federal right wing, a wild charge by about 700 Texans overwhelmed McRae's artillery battery, and the Union left wing collapsed. Canby ordered a retreat to Fort Craig.

The Confederates forced the Federal troops from the field and captured six cannons, but many of their mules and horses had been killed by Federal gunfire, fatally slowing their advance north toward Federal food and equipment depots. In addition, the failure to capture Fort Craig itself left a large Federal force threatening Sibley as he continued his march north.

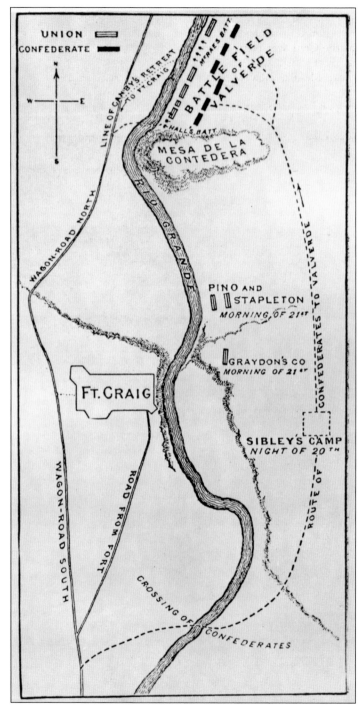

**Battle of Valverde Map.** The opposing sides battled along the mostly dry bed of the Rio Grande River on February 21, 1862. The weather was bitterly cold with snow and the Confederate troops suffered from hunger and exhaustion. Though the Coloradans in Dodd's Independent Company fought bravely, the Confederate onslaught against McRae's Battery decided the battle in favor of the Texans. (Courtesy of History Colorado 89.451.4936.)

**COL. JOHN BAYLOR.** Merciless Comanche fighter John Baylor of Texas assumed command of the 2nd Texas Cavalry as the Civil War began. Baylor's troops occupied Fort Bliss, then captured Fort Fillmore near Mesilla, New Mexico. News of Baylor's victories helped motivate Coloradans to respond by volunteering to fight for the Union. (Courtesy of History Colorado 2000.129.132.)

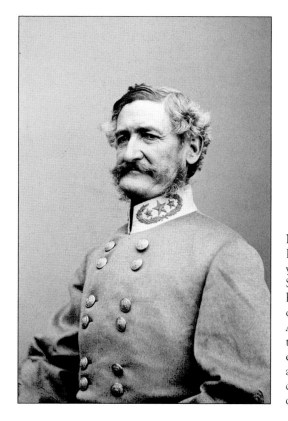

**BRIG. GEN. HENRY HOPKINS SIBLEY.** Henry H. Sibley served as a US Army officer for years in isolated frontier forts. When the Southern states seceded, Sibley resigned his commission, became a Confederate officer, and planned to secure the American Southwest and California for the Confederacy. Colorado volunteers were essential in thwarting Sibley's plans. Sibley's alcoholism and neglect of logistics also doomed his campaign. (Courtesy of Library of Congress.)

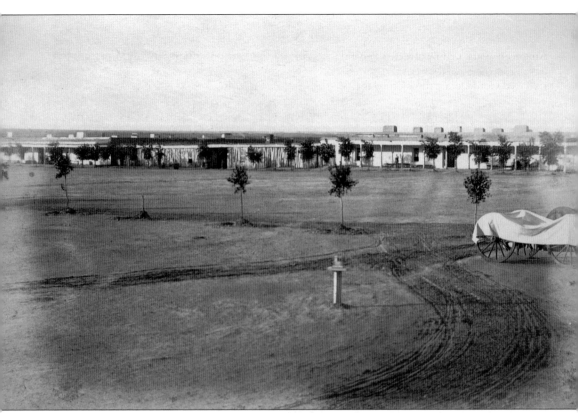

**FORT CRAIG, NEW MEXICO.** Established by the US Army in 1854, Fort Craig was one of several forts built after the Mexican-American War of 1846–1848 along El Camino Real, the old Spanish roadway connecting Mexico City and Santa Fe. The fort became a staging point and then refuge for Federal troops, including the Colorado volunteers, after the Battle of Valverde. (Courtesy of Palace of the Governors Photo Archive 014514.)

**COL. EDWARD S. CANBY.** A respected veteran of the Seminole and Mexican-American Wars, Canby directed Federal defense of the Southwestern territories. He faced Confederate invasion by the Sibley Brigade, harassment by irregular Confederate units, and incessant warfare between the Navajo and New Mexico's Hispanic people. Handicapped by the withdrawal of Federal troops, Canby's efforts were bolstered by the arrival of the Colorado Volunteers. (Courtesy of Library of Congress.)

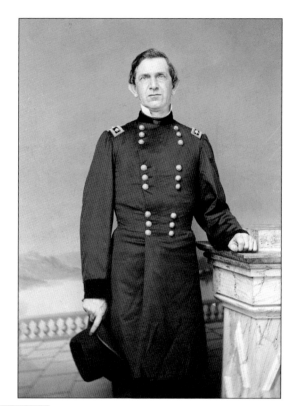

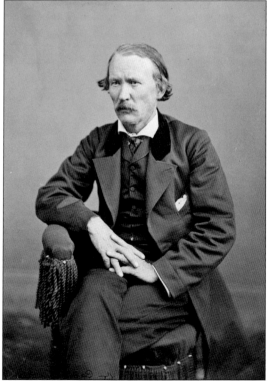

**COL. CHRISTOPHER "KIT" CARSON.** Kit Carson was already a legend as a trapper, hunter, and scout when the Civil War ignited. Appointed commander of the 1st New Mexico Volunteer Infantry, he trained his mostly Hispanic recruits at Fort Craig, awaiting battle with the Confederates. His men fought well at Valverde alongside the Colorado Volunteers. (Courtesy of Library of Congress.)

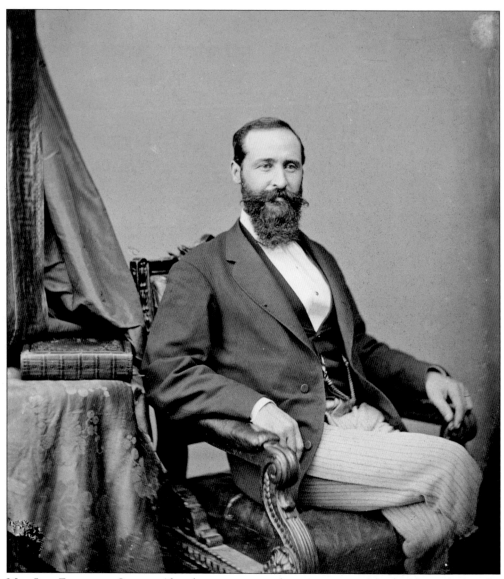

**Maj. Jose Francisco Chavez.** Already an experienced campaigner against the Navajo before the Civil War, Chavez was appointed major in the 1st New Mexico Volunteer Infantry, second-in-command to "Kit" Carson. He fought bravely at Valverde, then was ordered to establish Fort Wingate near San Rafael, New Mexico. He and his troops served throughout the New Mexico campaign, and afterward allied with the Coloradans. (Courtesy of Library of Congress.)

**MAJ. HENRY RAQUET.** Henry Racquet's family were successful merchants in Nacogdoches, Texas. Raquet was appointed major in the Sibley Brigade's 4th Texas Mounted Rifles, leading an unsuccessful charge at the Battle of Valverde against the Federal right flank. At the Battle of Glorieta Pass, he was killed leading a charge against Colorado troops on Sharpshooter's Ridge. (Courtesy of DeGolyer Library, Southern Methodist University, Lawrence T. Jones III Texas Photographs.)

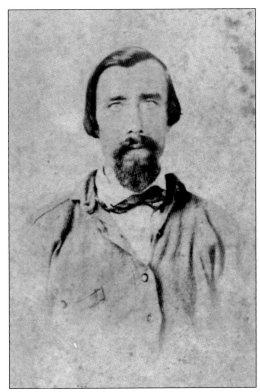

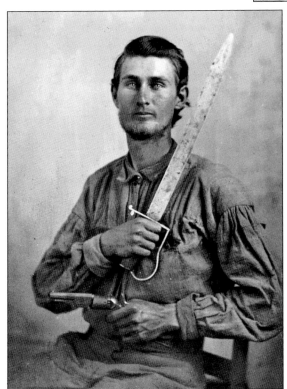

**SIMEON JASPER CREWS, SIBLEY BRIGADE.** Simeon Crews served in the 7th Texas Cavalry, and his clothing and weaponry are typical of early-war Texas volunteers. He wears a "battle shirt" and is armed with a tremendous "D-Guard" Bowie knife and a Colt "pocket model" revolver. Some of Sibley's men also wore captured Federal uniforms, causing confusion among Colorado troops at the Battle of Glorieta Pass. (Courtesy of Library of Congress.)

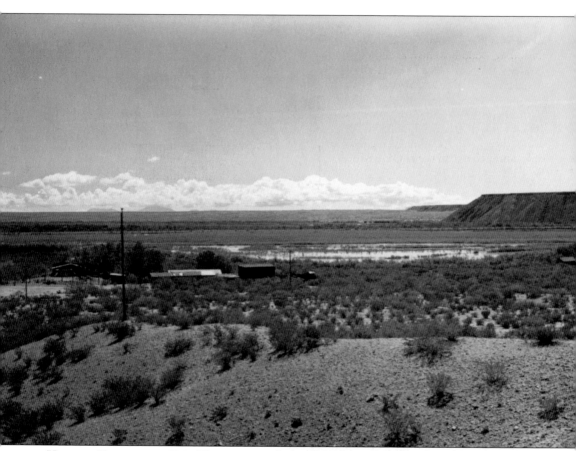

VALVERDE BATTLEFIELD, 1957. This view over the battlefield area shows the Rio Grande River, with the tabletop Mesa del Contadero on the right. Most fighting occurred north of the mesa. At the battle's end, Federal forces suffered about 263 casualties, and the Confederates 186. Colorado troops from Dodd's Independent Company served on the Federal right wing during the battle. (Photograph by John Buchanan, courtesy of History Colorado.)

**DODD'S INDEPENDENT COMPANY.** The Colorado "Pike's Peakers" led by Capt. Theodore Dodd marched 325 miles between Fort Garland and Fort Craig to fight in the Battle of Valverde. During the battle, they repelled the lancer charge by the 5th Texas Mounted Infantry, blasting half the Texas lancers out of their saddles, and defeating the only lancer charge of the entire Civil War. (Private collection.)

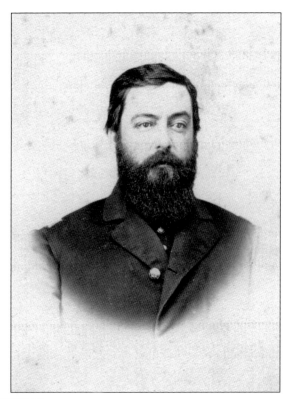

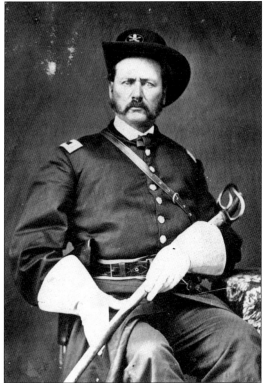

**CAPT. JOSEPH C.W. HALL.** Hall fought at the Battle of Valverde with Dodd's Independent Company. Later, he served as captain of Company B, 2nd Colorado Volunteer Infantry. When the 2nd Colorado was transferred to Missouri, Hall was appointed assistant provost-marshal of the 4th Sub-District of the District of Central Missouri, subduing Confederate guerrillas. He was promoted to major as the war ended. (Courtesy of History Colorado 91.429.315.)

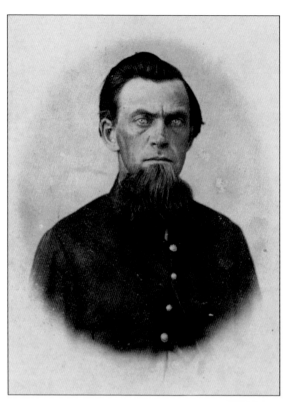

**SGT. MARTIN DEWITT PRENTICE.**
After fighting at Valverde in Dodd's Independent Company, Prentice served in the Indian Territory, Kansas, and Missouri with the 2nd Colorado Volunteer Infantry. Later, he met Mary Ann Laurie, who had been widowed during Quantrill's raid on Lawrence, Kansas, in August 1863. Prentice and Mary Ann married in September 1864. (Courtesy of History Colorado 91.429.26.)

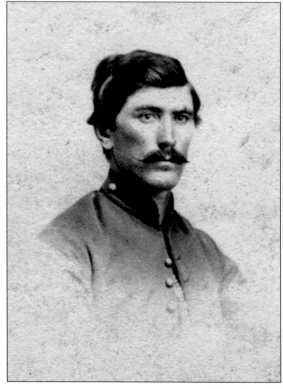

**PVT. ALONZO F. ICKIS.** Alonzo Ickis traveled to Colorado from Iowa with his brothers in 1859 in search of gold. Enlisting in Hendren's (later Dodd's) Independent Company, Ickis served through the 1862 New Mexico Campaign, then in Kansas and Missouri after his company became part of the 2nd Colorado Volunteer Infantry. His war service diary has been published. (Courtesy of History Colorado 91.429.663.)

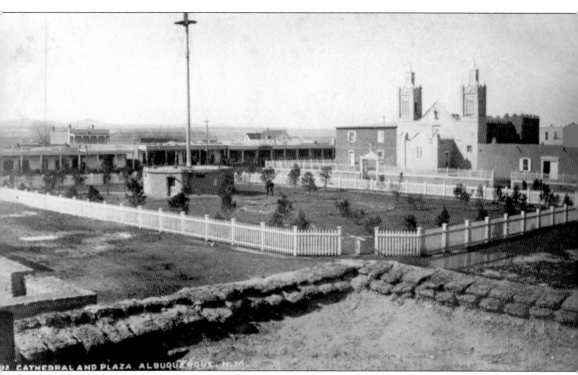

ALBUQUERQUE, NEW MEXICO. Albuquerque was one of the main targets in Sibley's campaign plan. He hoped to advance swiftly to the city, capturing its US Army stores of food, clothing, and ammunition. But the deaths of hundreds of mules and horses at Valverde slowed the Texans' advance. Federal troops managed to remove or burn most of the supplies before Sibley arrived. (Courtesy of Palace of the Governors Photo Archive 054084.)

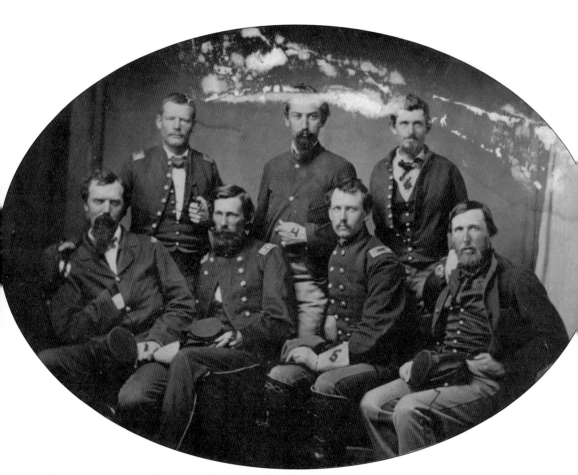

FIRST AND SECOND COLORADO OFFICERS. The day after the Battle of Valverde, the 1st Colorado Volunteer Infantry, including most of these officers, marched south from Denver for New Mexico. They include, from left to right, (first row) Capt. Samuel Robbins, Capt. John Hamilton, Maj. Edward Wynkoop, and Capt. (later Col.) James H. Ford; (second row) Capt. Silas Soule, Capt. James Shaffer, and Capt. Samuel Cook. (Courtesy of History Colorado 200,129.868.)

# Three

# GETTYSBURG OF THE WEST

Governor Gilpin was roused to action by urgent messages about the need for Federal reinforcements. On February 22, 1862, the 1st Colorado Volunteer Infantry marched out of Denver City, bound for Fort Union, New Mexico. When the regiment reached Raton Pass, word of the Federal defeat at Valverde arrived during a raging blizzard. The regiment made a forced march, arriving at Fort Union on March 10 after an epic journey of 400 miles in 13 days.

Pugnacious Colonel Slough sent Maj. John Chivington with 488 men south along the Santa Fe Trail from Fort Union through a mountainous route known as Glorieta Pass. On March 26, at Apache Canyon, Chivington collided with an equal number of Texans led by Maj. Charles Pyron. The impetuous Coloradans forced Pyron's men back through three successive positions, capturing 70 prisoners.

Two days later, the reinforced enemies met near Pigeon's Ranch along Glorieta Pass. Colonel Slough commanded about 800 men of the 1st Colorado, Ford's Independent Company, New Mexico Volunteers, and regular troops from several regiments. Col. William Scurry's 1,285 Texans assaulted the Federal troops repeatedly, with both sides hampered by rough terrain and thick forests. Scurry's men outflanked the Federals from positions on Windmill, Sharpshooter, and Artillery Hills, and Slough retreated from the battlefield.

Meanwhile, Major Chivington with 488 men climbed up Glorieta Mesa with the intent of attacking the Confederates from the rear. Instead, he discovered the entire Confederate 80-wagon supply train, guarded by only about 200 men. Scrambling down the steep mesa, the Coloradans routed the guards, destroying the supplies necessary for the Sibley Brigade's survival. Because of the decisive results of the Glorieta Pass action, the battle was dubbed the "Gettysburg of the West." Estimated casualties include 48 Confederates killed, 60 wounded, and 25 captured; and 48 Federals killed, 70 wounded, and 21 captured.

The Sibley Brigade had no choice but to retreat to Texas. They clashed with pursuing Federals at Peralta but were able to continue. Many dropped from hunger, thirst, and exhaustion during the agonizing journey. Only about half of the original Sibley Brigade made it back to Texas.

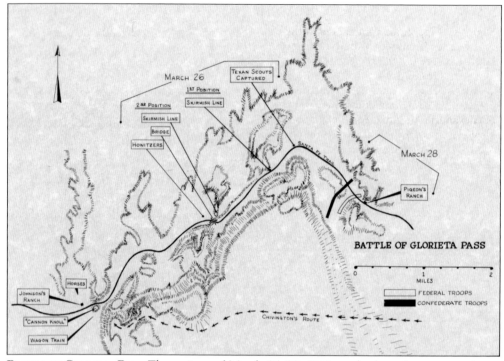

**Battle of Glorieta Pass.** The actions of March 26–28, 1862, took place along mountainous areas of the Santa Fe Trail known as Apache Canyon and Glorieta Pass. The rugged, wooded terrain both limited visibility and dictated where the crucial action would happen. (Courtesy of History Colorado G4323.S5S1 1862.A7 Map.)

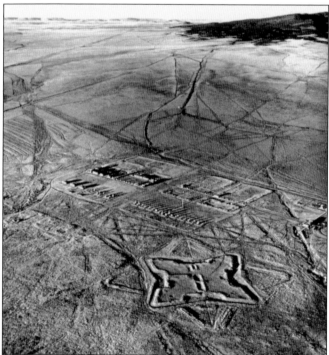

**Fort Union, New Mexico (Star Fort).** This 1930s aerial photograph shows the second Fort Union, the "Star Fort," an earthworks fortification built to defend against Confederate attack a mile from the original post. Located in New Mexico at the vital junction of the Mountain and Cimarron branches of the Santa Fe Trail, Fort Union's defense was the prime mission of the Colorado Volunteers. (Courtesy of National Park Service, Fort Union National Monument.)

COL. JOHN SLOUGH. Denver attorney John Slough was appointed commander of the 1st Colorado Volunteer Infantry. At the Battle of Glorieta Pass, the highly unpopular Slough hid from his own men shooting at him. He resigned and left Colorado, eventually commanding the Military District of Alexandria, Virginia. As chief justice of New Mexico after the war, he was murdered during a legal dispute. (Courtesy of Library of Congress.)

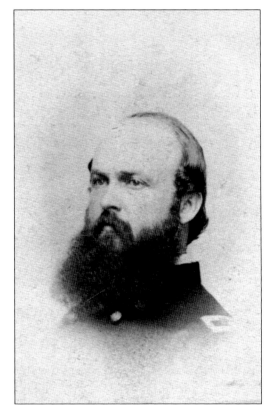

COL. JOHN M. CHIVINGTON. Methodist minister John Chivington fearlessly preached the gospel before being appointed major of the 1st Colorado Volunteer Infantry. His destruction of the Confederate wagons at Glorieta Pass in 1862 ensured Confederate defeat. Succeeding Slough as commander of the 1st Colorado, Chivington led the troops at the infamous Sand Creek Massacre of peaceful Cheyenne and Arapaho people in November 1864. (Courtesy of History Colorado 89.451.5534.)

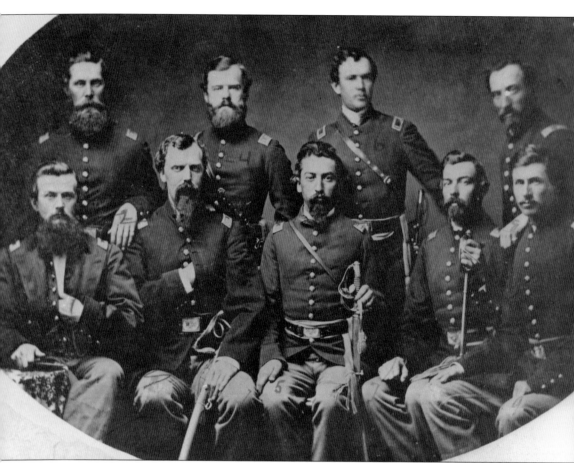

**1st Colorado Volunteer Cavalry Officers, c. 1863.** From left to right are (first row) Maj. Scott J. Anthony, Capt. Samuel Robbins, Capt. James Shaffer, unidentified, and Capt. Charles Kerber; (second row) unidentified, Capt. George Kimball, and two unidentified. Names listed on the back of the photograph include Capt. Isaac Gray, Capt. William B. Moore, Capt. Edward Jacobs, and Lt. Samuel N. Crane. (Courtesy of History Colorado 2000.129.866.)

**Fr. John Kehler.** Marylander John Kehler, originally a Lutheran minister, converted to the Episcopalian Church. He followed several sons to Colorado in 1860, founding the first Episcopalian congregation in the territory and establishing St. John's in the Wilderness Church. When the Civil War came, he volunteered as chaplain of the 1st Colorado Volunteer Infantry, serving with the troops in the field in his mid-60s. (Courtesy of History Colorado 89.451.3115.)

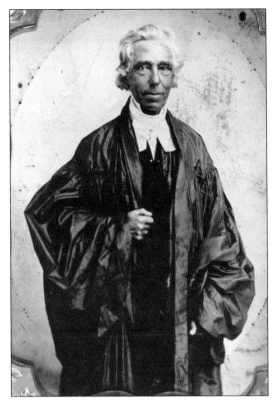

**Entrance to Apache Canyon.** Apache Canyon is a narrow passage on the Glorieta Pass route of the Santa Fe Trail. On March 26, 1862, Coloradans and Texans, each about 410–440 men strong, clashed here. Amid a confused, disorganized melee, the Texans were flanked out of three successive positions before fighting ended that night, even though they were supported by two artillery pieces. (Courtesy of History Colorado Neg. No. 42722.)

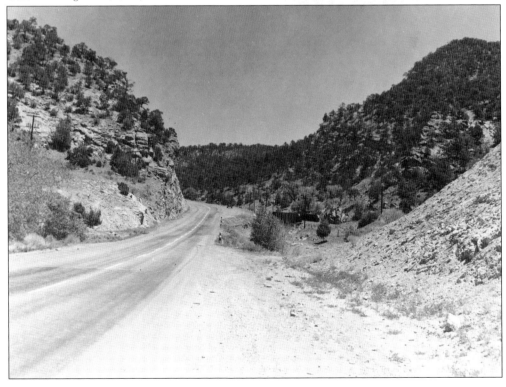

APACHE CANYON BATTLEFIELD. Apache Canyon is crossed by deep arroyos, and it was on this bridge over Galisteo Creek that the men of the 1st Colorado's mounted Company F waited to charge the Texans. They lost three men killed and five wounded during their charge. Another wounded officer, Lt. Charles Marshall, shot himself accidentally and died after the skirmish. (Courtesy of History Colorado 89.451.4922.)

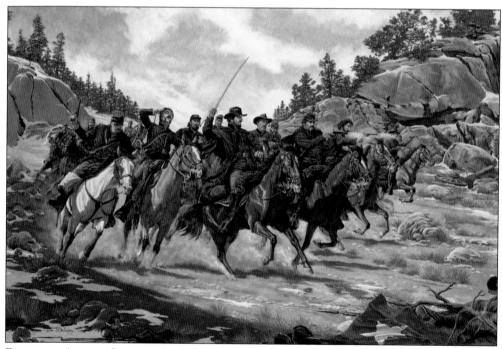

BATTLE OF APACHE CANYON. As Coloradans and Texans clashed in Apache Canyon, one of the most dramatic incidents was the charge of the 1st Colorado's mounted Company F as they reportedly leapt an arroyo to attack the Confederates. The Texans were forced to retreat by the impetuous Coloradans led by Maj. John M. Chivington. (Painting by Domenick D'Andrea, Courtesy of National Park Service.)

**Capt. Samuel Cook.** Captain Cook commanded mounted Company F of the 1st Colorado Volunteer Infantry. Leading the charge against Confederate troops at Apache Canyon, Cook's horse was killed and fell on him, then he was wounded in the thigh and foot. Confederate and Federal troops swirled around him in a chaotic melee. Cook recovered, serving through the end of the war. (Courtesy of Denver Public Library Western History Collection Z-527.)

**Kozlowski's Ranch, Glorieta Pass.** One of the Santa Fe Trail way stations, Martin Kozlowski's Ranch was about a mile southeast of the Pecos Pueblo ruins. With abundant water nearby, it became an encampment of Colorado troops during the battles of Apache Canyon and Glorieta Pass and was used as a field hospital. This 1905 photograph shows Kozlowski in front of his main ranch building. (Courtesy of History Colorado 89.451.4931.)

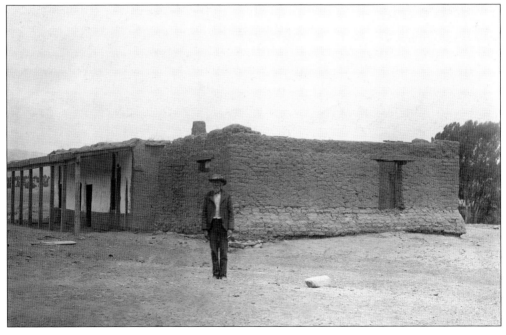

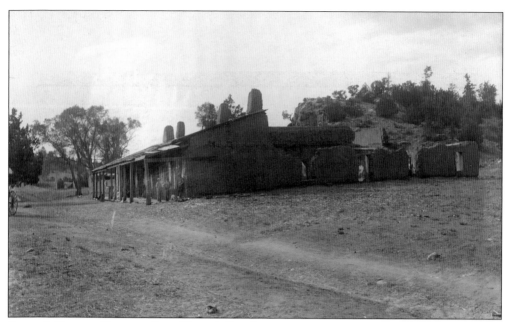

PIGEON'S RANCH, GLORIETA PASS. Pigeon's Ranch was an important stop on the Santa Fe Trail, with a main adobe ranch house, corrals, and other outbuildings. It was a highly defensible position in a narrow valley dominated by what was later called Artillery Hill. The ranch formed the center of the 1st Colorado battle line during the later phases of the Battle of Glorieta Pass. (Courtesy of History Colorado 89.451.4932.)

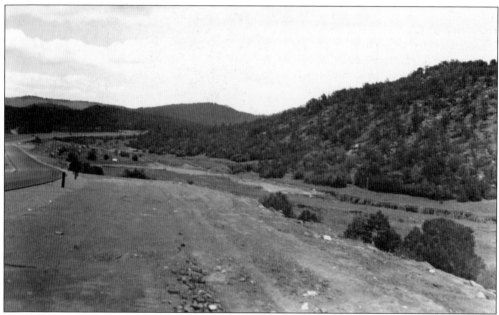

GLORIETA BATTLEFIELD. This 1957 photograph gives an idea of the appearance of the old Santa Fe Trail route through Glorieta Pass. The narrow passageway through the mountains was dominated by several hills, which made possession of these high points crucial to victory or defeat in the intense fighting of March 26 and 28, 1862. The Coloradans fought fiercely to hold these positions. (Courtesy of History Colorado PH. PROP.4483.)

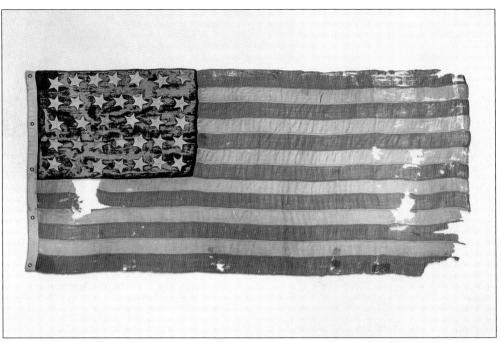

**1st Colorado Volunteer Infantry Battle Flag.** This wool bunting and cotton flag was carried by the 1st Colorado during the Battle of Glorieta Pass, pierced by Confederate canister and bullet holes. Cherished by color bearer Michael Ivory and donated to the Colorado State Historical Society (now History Colorado), it was put on display by History Colorado in 2017 after a lengthy conservation process. (Courtesy of History Colorado WR.1104.1.)

**Maj. John Samuel Shropshire.** Shropshire, a Kentuckian, moved to Texas in the 1850s, becoming a prosperous plantation and slave owner who, ironically, opposed secession. Shropshire enlisted in the 5th Texas Mounted Rifles and was appointed major. At the Battle of Glorieta Pass, he was killed while leading an unsuccessful charge on the Coloradans. His body, discovered in 1987, was returned to his Kentucky family. (Courtesy of Nesbitt Memorial Library Archives.)

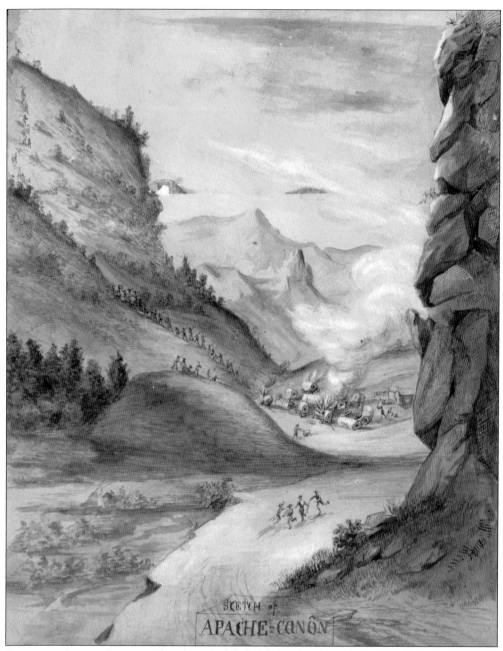

SKETCH OF APACHE CANYON. This drawing labeled "Sketch of Apache Canyon" shows Colorado troops scrambling back up the steep slopes of Glorieta Mesa after destroying the Confederate supply wagons at the base of the mesa. This action sealed the fate of the Confederate invasion of New Mexico, forcing the Sibley Brigade into a lengthy, agonizing retreat to Texas over mountains and through the desert country. (Courtesy of History Colorado 89.451.4923.)

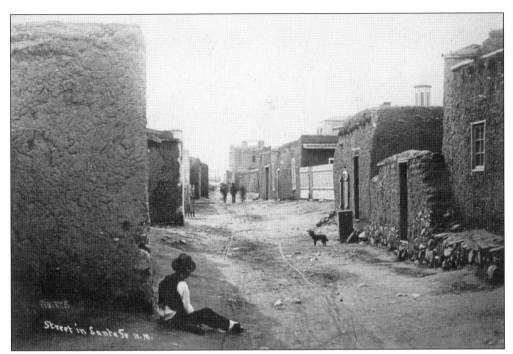

Street in Santa Fe N.M.

**SANTA FE STREET, 1870S.** Though it was the capital of New Mexico Territory, Santa Fe in the 1860s was not the manicured tourist destination of today. Travelers invariably described it as dirty, dusty, and filled with taverns and brothels, as befitted the Santa Fe Trail's ultimate destination. The Sibley Brigade occupied the city without a fight on March 10, 1862. (Courtesy of Denver Public Library, Western History Collection Z-1149.)

**LOUISA HAWKINS CANBY.** Col. Edward Canby's wife, Louisa, was trapped in Santa Fe when the Confederates occupied the city. As the Confederate wounded arrived in Santa Fe from Glorieta Pass, she organized local women to nurse them, gather blankets, and build improvised ambulances. The Texans dubbed her the "Angel of Santa Fe." The large number of wounded demonstrated the effectiveness of the Colorado troops. (Courtesy of Filson Historical Society, Louisville, Kentucky.)

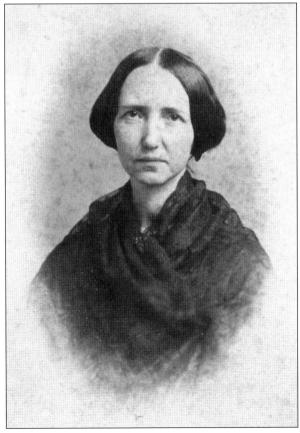

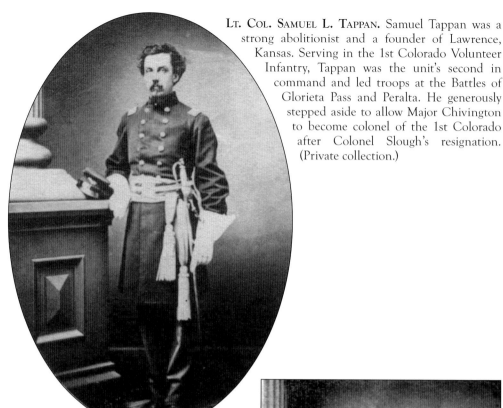

**Lt. Col. Samuel L. Tappan.** Samuel Tappan was a strong abolitionist and a founder of Lawrence, Kansas. Serving in the 1st Colorado Volunteer Infantry, Tappan was the unit's second in command and led troops at the Battles of Glorieta Pass and Peralta. He generously stepped aside to allow Major Chivington to become colonel of the 1st Colorado after Colonel Slough's resignation. (Private collection.)

**Assistant Surgeon Larkin C. Tolles.** Vermonter Larkin Tolles attended Dartmouth and Vermont Medical College, earning his medical degree in 1854. An ardent abolitionist, Tolles moved to Lawrence, Kansas, and then to Colorado in 1861. Appointed assistant surgeon in the 1st Colorado Volunteer Infantry, Tolles tended the wounded during the entire New Mexico campaign. He served throughout the war, later practicing medicine in Central City and Denver. (Private collection.)

46

FIRST LT. JOHN C. ANDERSON. Anderson was the regimental quartermaster for the 1st Colorado, managing regimental funds to purchase food, clothing, blankets, uniforms, bedding, tents, and all other necessary supplies. In addition, he had to organize transportation for all these items so they could be distributed to the troops. Anderson served as a second lieutenant in Companies C and G during the New Mexico campaign. (Courtesy of History Colorado 91.429.566.)

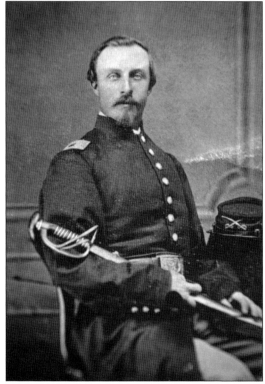

CAPT. GEORGE L. SANBORN. Captain Sanborn proudly holds the cavalry saber he wielded as commanding officer of Company H, 1st Colorado Volunteer Infantry. Sanborn served throughout the New Mexico campaign. Later, his company ignited the 1864 Colorado Territory War by attacking a Cheyenne camp at Fremont's Orchard on April 12, 1864. The company also participated in the Sand Creek Massacre on November 29, 1864. (Courtesy of History Colorado 89.541.3441.)

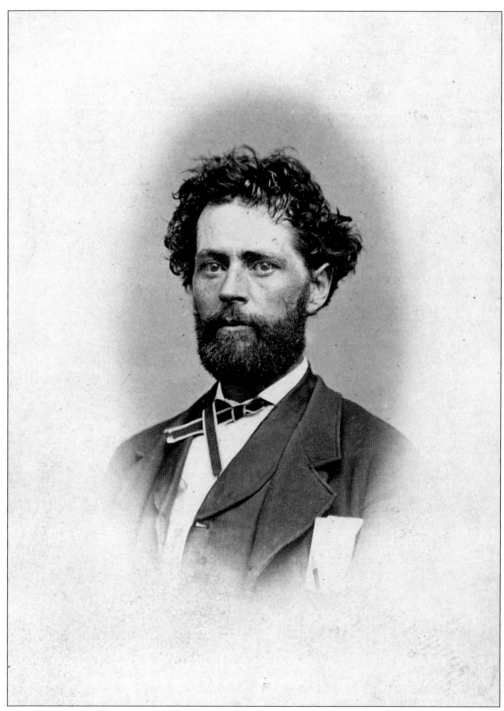

**Pvt. Ovando J. Hollister.** Hollister served in Company F, 1st Colorado Volunteer Infantry during the New Mexico campaign. He fought at Apache Canyon and at the Battle of Glorieta Pass. Returning to Denver, in 1863, he wrote *A History of the First Regiment Colorado Volunteers*, which has been republished as *Boldly They Rode*. He later moved to Utah. (Courtesy of History Colorado 91.429.263.)

**Lt. George W. Hawkins.** Hawkins served as a first lieutenant in Companies A and B of the 1st Colorado Volunteer Infantry (later converted to Cavalry). One document says he was wounded in the left hand at "Pigeon's Roost," a battle in West Virginia. This is undoubtedly a mistake, as the real location is Pigeon's Ranch (Glorieta Pass). Hawkins was an engineer and machinist. (Courtesy of History Colorado 95.200.1674.)

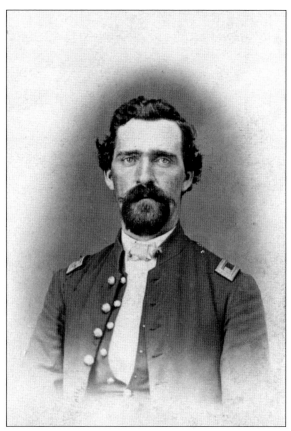

**Springfield Rifle.** This Springfield Model 1861 US Army rifle-musket was found—still loaded, with bayonet fixed—in an abandoned building in Bernal Springs, New Mexico, in 2015. It is marked with a "Z" in front of the trigger guard, indicating a Federal weapon captured by the Confederacy and reissued. It was possibly used by one of the Colorado troops and left behind. (Private collection.)

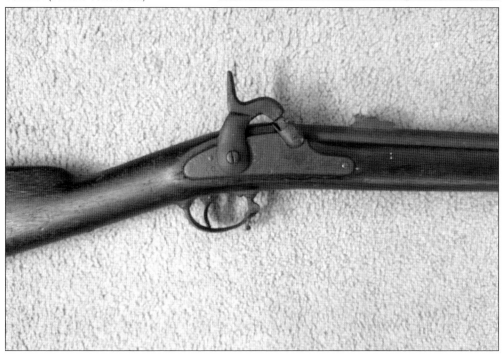

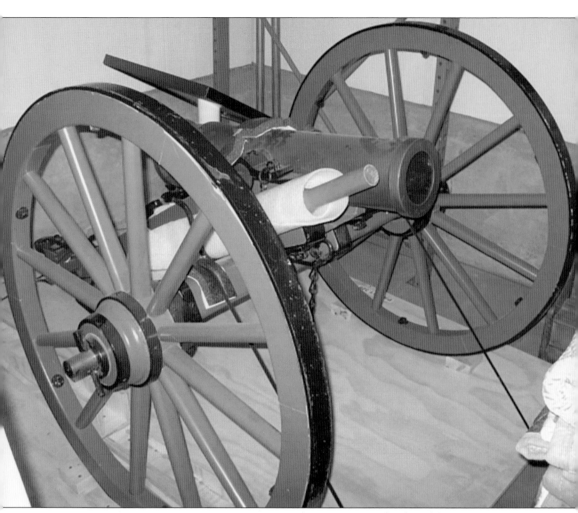

TWELVE-POUND MOUNTAIN HOWITZER. Mountain howitzers were developed by the US Army in the 1840s. This howitzer was one of eight buried by the Sibley Brigade when they evacuated Albuquerque, avoiding capture by the Colorado troops. In 1889, Maj. Trevanion Teel, who had commanded the Sibley Brigade's artillery, returned to Albuquerque and revealed where the guns were. Today, two of them are held by History Colorado. (Courtesy of History Colorado H.6000.2.D.)

# *Four*

# REINFORCEMENTS

Despite the victory of the 1st Colorado Volunteers in New Mexico, additional troops were urgently needed. The 2nd Colorado Volunteer Infantry was authorized in February 1862, led by Col. Jesse Leavenworth. Leavenworth recruited near his Wisconsin home, arriving in Denver by May 1862 with four companies and an artillery battery, the 9th Wisconsin Independent Battery Light Artillery. Ford's and Dodd's Independent Companies were added to the regiment, and eventually, it included eight full companies. Leavenworth also organized McLain's Independent Battery, Colorado Light Artillery.

A 3rd Colorado Volunteer Infantry unit was organized at Camp Weld in the fall of 1862. Even with the assistance of its first commander, William Larimer, only seven companies were recruited from the mountain mining towns, and James H. Ford took over command as their colonel. The troops were ordered east through Kansas and Missouri, enduring horrendous winter weather. They built Fort Davidson at Pilot Knob, Missouri, and occupied nearby Potosi and Ironton until October 1863.

The 2nd Colorado Volunteer Infantry split, with six companies under its second-in-command, Lt. Col. Theodore Dodd, ordered to the Indian Territory. There, they fought in the battles of Honey Springs, Cabin Creek, and Perryville from May through August 1863, gaining control of the Indian Territory for the Union. The remainder of the regiment, under Colonel Leavenworth, assisted by other volunteer units, guarded the Santa Fe Trail from Fort Larned, Kansas, to Fort Lyon, Colorado Territory.

By late 1863, it became obvious that infantry units were unable to travel the vast Western distances fast enough to intercept highly mobile mounted hostile warriors or Confederate guerrillas. In November 1863, the 1st Colorado Volunteer Infantry was converted into the 1st Colorado Volunteer Cavalry, serving along the Santa Fe Trail and the Overland Trail in Colorado. The other two Colorado infantry units assembled in St. Louis by December 1863 and were combined into the 2nd Colorado Volunteer Cavalry. James H. Ford assumed command of the new cavalry regiment, known as the "Rocky Mountain Rangers." This regiment would endure a year of the most intense action of any Colorado unit during the Civil War.

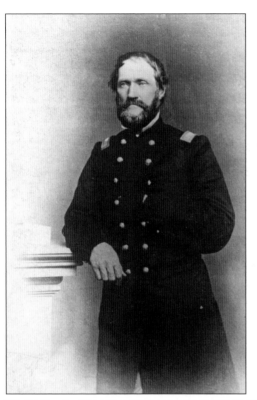

COL. JESSE H. LEAVENWORTH. Son of Gen. Henry Leavenworth, West Pointer Jesse Leavenworth worked as a civil engineer after his Army service. Appointed colonel of the 2nd Colorado Volunteer Infantry in 1862, Leavenworth maintained good relationships with the Plains tribes. Dishonorably discharged for unauthorized recruitment of an artillery battery, Leavenworth was appointed Indian agent for the Comanche, Kiowa, and Plains Apache. (Courtesy of History Colorado Neg. No. F-26,174.)

RECRUITING POSTER, 3RD COLORADO INFANTRY. The 3rd Colorado Volunteer Infantry regiment was authorized and began recruiting in August 1862. Most of the men in its five companies came from the mining communities. With many people leaving Colorado because of a mining slump, the unit never recruited up to its authorized strength. The regiment, commanded by Col. James Ford, was eventually ordered to Missouri. (Courtesy of History Colorado PH. PROP.5426.)

## RECRUITS WANTED !!

Having been appointed to raise a Company of

# SHARP SHOOTERS

from the Hunters of the Rocky Mountains and the Arkansas Valley,

## FOR THE THIRD REGIMENT

Colorado Volunteers, to proceed to the States as soon as organized, under command of

## COL. J. H. FORD.

I am now ready to receive recruits at my head quarters at Canon City.

## HUNTERS COME FORWARD AND JOIN

The Crack Company of the Crack Regiment.   As this is to be picked Company none but good able bodied men need apply.                    DAVID P. WILSON, Recruiting Officer.

Commonweal & Republican Steam Press Print, Denver.

**2ND COLORADO OFFICERS.**
Posing probably in 1864
are most of the 2nd
Colorado Volunteer
Cavalry command staff.
From left to right are
(first row) surgeon Irving
J. Pollock, Col. James H.
Ford, and Maj. Jesse L.
Pritchard; (second row)
quartermaster 1st Lt.
Guy C. Manville, 1st Lt./
Adj. Robert S. Roe, and
assistant surgeon George
S. Aikin. (Courtesy
of History Colorado
2000.129.866.)

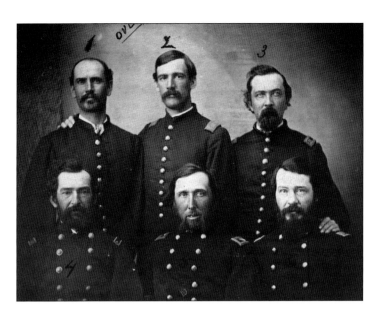

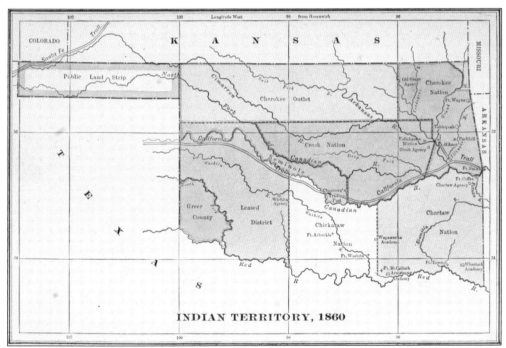

MAP OF INDIAN TERRITORY. The US government divided present-day Oklahoma into tribal enclaves. The Indian Removal Act of 1830 tore people away from their traditional homelands, while there were also previous voluntary migrations. The Five "Civilized" tribes— Cherokee, Creek, Chickasaw, Choctaw, and Seminole—were allotted large areas, which shrank enormously in the late 1800s because of changes in government land policy. (Courtesy of Internet Archive Book Images, www.flickr.com.)

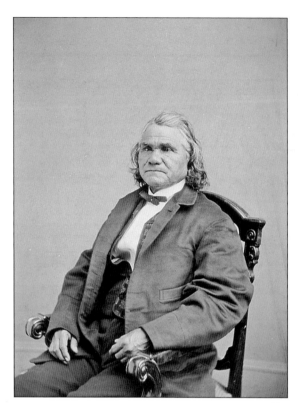

CHIEF STAND WATIE. Cherokee leader Stand Watie was embroiled in divisive tribal politics before the Civil War, resulting in his support of the Confederacy. As commander of the 1st Cherokee Mounted Rifles, he was a fierce opponent to Colorado troops in the Indian Territory. By 1864, he was promoted to brigadier general. On June 23, 1865, Stand Watie became the last Confederate general to surrender. (Courtesy of National Archives.)

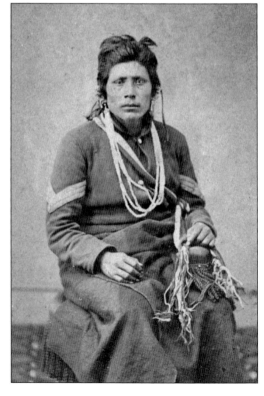

NATIVE AMERICAN FEDERAL SERGEANT. During the Civil War, various Native American tribes divided into Northern and Southern factions in their own internal Civil War. The Cherokee, Choctaw, Creek, Chickasaw, and Seminole tribes all separated into opposing factions resulting from longstanding tribal controversies. Both sides formed Native American units, and the Confederate Congress included delegates from the Cherokee Nation. (Courtesy of Library of Congress.)

**1ST KANSAS COLORED VOLUNTEERS.** The 1st Kansas Colored Volunteer Infantry was recruited even before the enlistment of African Americans was officially authorized. Many men were former slaves. It was the first African American unit to fight during the Civil War, in October 1862 at Island Mound, Missouri. Later, the 1st Kansas fought alongside the 2nd Colorado at Honey Springs and Cabin Creek, Indian Territory. (Courtesy of Kansas Historical Society.)

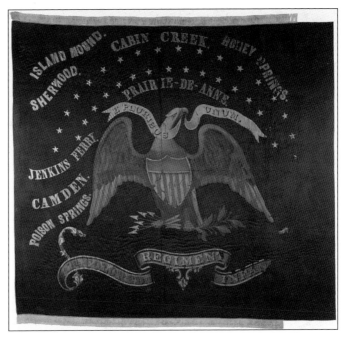

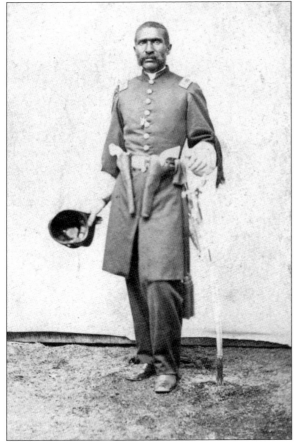

**LT. WILLIAM MATTHEWS.** Born a slave in Maryland, by the 1850s, William Matthews lived in Kansas, involved with the Underground Railroad. When the Civil War began, Matthews recruited a full company for the 1st Kansas Colored Volunteer Infantry, destined to fight in the Indian Territory alongside the 2nd Colorado. Later, he served as first lieutenant in the Independent Battery, US Colored Light Artillery. (Courtesy of Kansas Historical Society.)

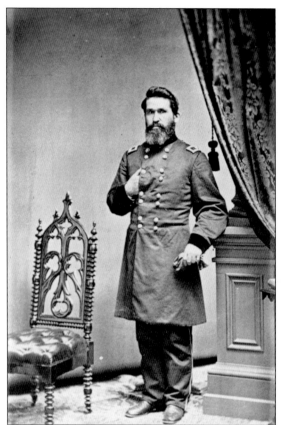

**Brig. Gen. James Blunt.** Determined to gain control of the Indian Territory for the Union, Brig Gen. James Blunt organized the 1st Kansas Home Guard (Creeks and Seminoles), 2nd Kansas Home Guard (Cherokees, Creeks, Chickasaws, Osages, and Seminoles), and 3rd Kansas Home Guard (mostly deserters from a Cherokee regiment). (Courtesy of Library of Congress.)

**Battle of Honey Springs.** Fort Gibson in Indian Territory was in danger of a Confederate attack in the summer of 1863. Brig. Gen. James Blunt assembled about 3,000 men at the fort, including six companies of the 2nd Colorado Volunteer Infantry. Crossing the Arkansas River, they attacked the Confederate forces at Honey Springs on July 17, 1863. The Confederates were routed, securing Federal control of Indian Territory. (Courtesy of Library of Congress.)

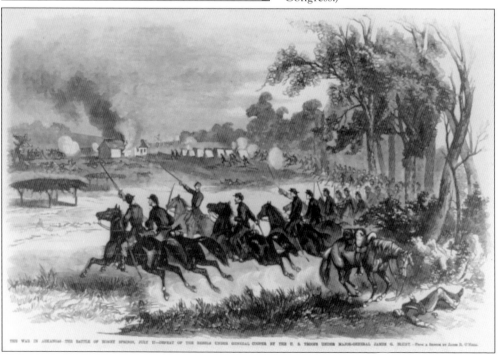

THE WAR IN ARKANSAS THE BATTLE OF HONEY SPRINGS, JULY 17—DEFEAT OF THE REBELS UNDER GENERAL COOPER BY THE U. S. TROOPS UNDER MAJOR-GENERAL JAMES G. BLUNT.—From a Sketch by Alonzo D. O'Neil.

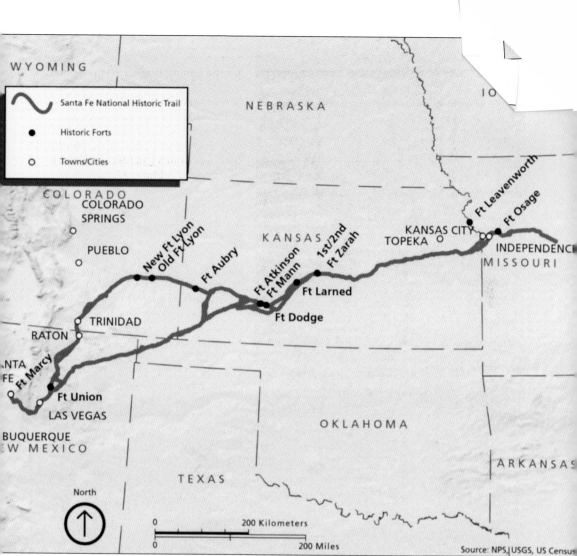

**SANTA FE TRAIL MAP.** Colorado troops served extensively along the Santa Fe Trail. Several Colorado officers, including Col. Jesse Leavenworth, Maj. Scott Anthony, Capt. William H. Backus, and Capt. Thomas M. Moses commanded at Fort Larned. Coloradans guarded wagon trains, escorted the mails, and patrolled the trail, as well as garrisoning Forts Zarah, Larned, Dodge, Lyon, and Union. (Courtesy of National Park Service.)

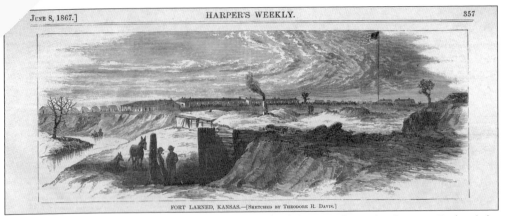

FORT LARNED, KANSAS.—[SKETCHED BY THEODORE R. DAVIS.]

**FORT LARNED, KANSAS.** Established in 1859 as a mail station along the Pawnee Fork of the Arkansas River, during the Civil War, Fort Larned became a vital Santa Fe Trail stronghold. Colorado troops were often stationed there. It became headquarters for Col. Jesse Leavenworth both as commander of the 2nd Colorado Volunteer Infantry and later as Indian agent for the Comanche, Kiowa, and Plains Apache. (Author's collection.)

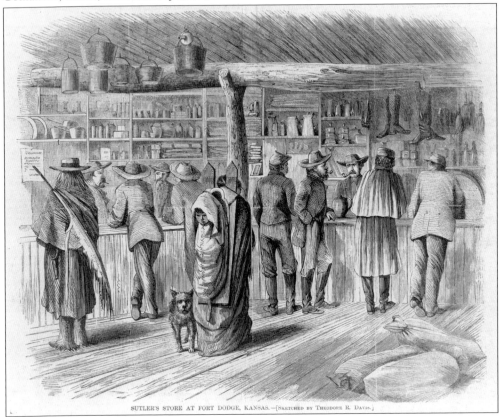

SUTLER'S STORE AT FORT DODGE, KANSAS.—[SKETCHED BY THEODORE R. DAVIS.]

**FORT DODGE SUTLER STORE.** Each substantial fort had a store, operated by a "sutler" licensed to sell goods to the troops. These stores, the ancestors of post exchanges, offered food, clothing, personal effects, and other items absent from the meager Army issue equipment. Soldiers of the 1st and 2nd Colorado would have been very familiar with this store when they served at the fort. (Courtesy of Library of Congress.)

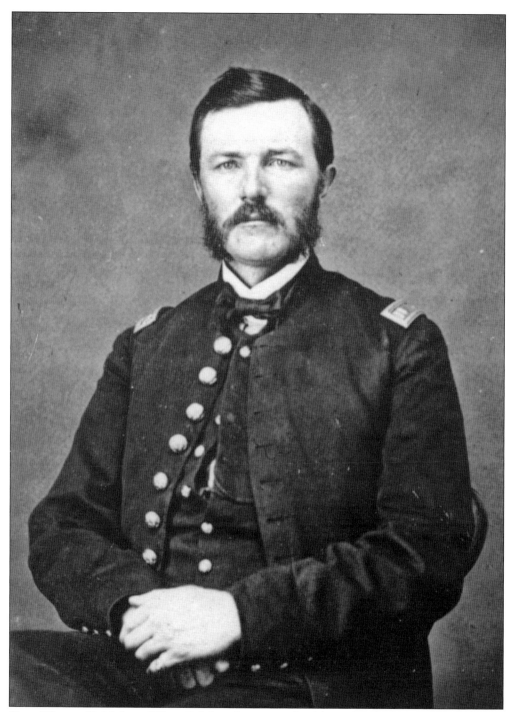

CAPT. WILLIAM D. MCLAIN. When Col. Jesse Leavenworth of the 2nd Colorado Volunteer Infantry arrived in Colorado, he recruited and equipped an artillery battery without authorization from the US War Department. Capt. W.D. McLain commanded this artillery battery. It served not only in Colorado Territory, but during all the major battles during Price's Raid throughout eastern Kansas in 1864. (Courtesy of History Colorado Neg. No. F-6470.)

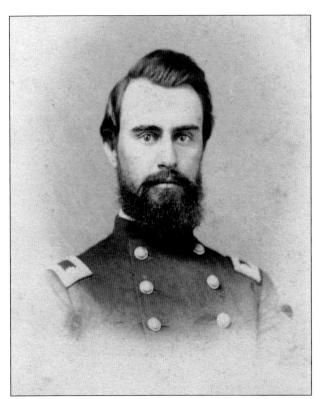

**LT. COL. SAMUEL S. CURTIS.**
One of Denver City's founders,
Curtis was appointed major of
the 2nd Colorado Volunteer
Infantry in 1862. After the unit
joined with the 3rd Colorado
Volunteer Infantry to form the
2nd Colorado Volunteer Cavalry,
Curtis and his regiment battled
Confederate guerrillas in Missouri
and helped repel Price's Raid in
1864. Curtis was the son of Maj.
Gen. Samuel R. Curtis. (Private
collection.)

**LT. COL. THEODORE DODD.** In 1863,
Dodd led six companies of the
2nd Colorado Volunteer Infantry
South, escorting Federal supply
wagons on the Texas Road to Fort
Gibson, Indian Territory. In the
ensuing campaign, the 2nd fought
pitched battles with Confederate
forces at Honey Springs, Cabin
Creek, and Perryville, together
with African American troops of
the 1st Kansas Colored Infantry
and Native American Federal
soldiers. (Courtesy of History
Colorado 2000.129.772.)

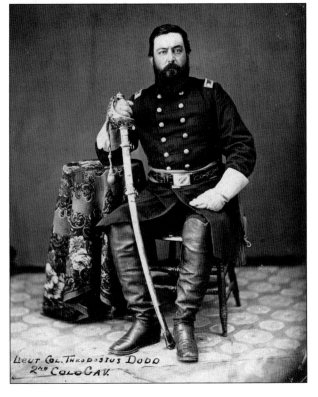

**Capt. Edward P. Elmer.** Originally enlisted as a first lieutenant in the 3rd Colorado Volunteer Infantry, Elmer was promoted to captain of his company. When the 2nd and 3rd Colorado Infantry were consolidated into the 2nd Colorado Volunteer Cavalry, Elmer became captain of Company K. He ably led his company in action against Confederate guerrillas in Missouri and was considered indispensable by Col. James Ford. (Private collection.)

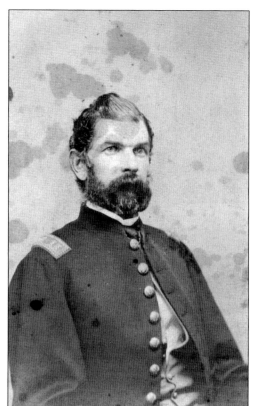

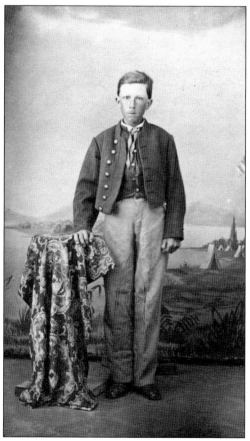

**Pvt. Gordon C. Smart.** Childlike Pvt. Gordon Smart enlisted at Central City in mid-May 1862, in the 2nd Colorado Volunteer Infantry. He continued to serve through the unit's consolidation with the 3rd Colorado Volunteer Infantry and conversion into cavalry, a fact confirmed by the highly visible cloth reinforcement on the inside legs of his cavalry trousers. He mustered out on June 19, 1865. (Private collection.)

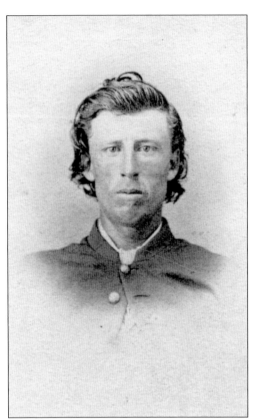

**Pvt. Albert H. Smart.** Albert Smart followed his brother into the service, enlisting in May 1862 at Central City. He served in Company E of the 2nd Colorado Volunteer Infantry, which became Company C of the 2nd Colorado Volunteer Cavalry when the 2nd and 3rd Colorado Infantry regiments were consolidated into a single cavalry regiment. (Private collection.)

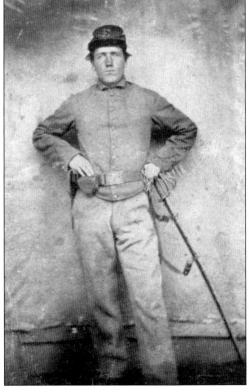

**Pvt. Theodore Hess.** Private Hess served in Companies E and F of the 1st Colorado Volunteer Infantry (later Cavalry). The "E" on his forage cap indicates his company, and he wears an issue mounted service jacket with the yellow trim removed, typical of the Colorado volunteers. He is well-armed with a revolver on his right hip, percussion cap pouch, and Model 1860 US cavalry saber. (Private collection.)

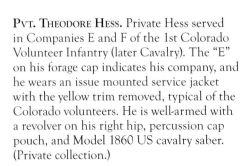

# Five

# FIGHTING QUANTRILL
# AND "PAP" PRICE

After the 2nd Colorado Volunteer Cavalry was organized in late 1863, the men plunged into the savage and merciless world of guerrilla warfare in Missouri. They dealt with raids of increasing intensity as foliage leafed out in the spring, offering forage for guerrilla forces. In August came the horrific guerrilla raid on Lawrence, Kansas, and the ensuing Order No. 11, an attempt to depopulate four Missouri counties seen as hotbeds of guerrilla activity.

The guerrilla units sometimes counted several hundred men, led by charismatic leaders such as William Quantrill, "Bloody Bill" Anderson, Dick Yeager, and George Todd. Familiar with the local terrain, they often disguised themselves in Federal uniforms and were sheltered by the local population. Despite these obstacles, Colonel Ford and his men proved skillful at counterinsurgency warfare. The 2nd Colorado, aided by the Missouri State Militia, occupied strategic towns and crossroads, riding on patrols that totaled several thousand miles.

By October 1864, Federal forces in Missouri faced an even greater challenge: a full-scale invasion by 12,000 Confederate troops advancing from Arkansas, led by Maj. Gen. Sterling "Pap" Price. Joined by 5,000–6,000 guerrillas, Price's objective was to capture Missouri for the Confederacy. Barred from St. Louis by Federal cavalry led by Maj. Gen. Alfred Pleasanton, Price moved northwest to capture Kansas City. The 2nd Colorado and McLain's battery were among the Federal forces fighting delaying actions until Maj. Gen. Samuel Curtis could gather sufficient Federal troops, unite with Pleasanton, and defeat Price. Fighting stubbornly at the Little Blue and Big Blue Rivers, the Coloradans were not present at the climactic Battle of Westport, where Price's army was overwhelmingly crushed and forced to retreat to Arkansas. Pursuing the retreating Confederates, the 2nd Colorado fought them at Newtonia, Missouri, on October 28, taking heavy casualties.

After Price's defeat, Colonel Ford was promoted to brigadier general and placed in command of the District of Upper Arkansas. During the spring and summer of 1865, the 2nd Colorado joined the 1st Colorado at Fort Larned and other posts, guarding the Santa Fe Trail against vengeful tribal warriors in the wake of the Sand Creek Massacre.

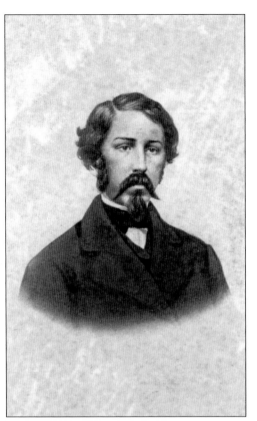

**WILLIAM CLARK QUANTRILL.** Most notorious of all Confederate guerrilla leaders during the Civil War, Quantrill gathered a force of hundreds of "bushwhackers," leading them in a merciless series of murders and atrocities across Missouri and Kansas. His bushwhackers almost captured Federal district commander Brig. Gen. James Blunt. Eventually, other guerrilla leaders eclipsed Quantrill, and he was killed in a raid on Louisville, Kentucky, in 1865. (Courtesy of Library of Congress.)

**ATTACK ON LAWRENCE, KANSAS.** Lawrence, Kansas, was a center for abolitionist activity during the "Bleeding Kansas" conflict between pro- and anti-slavery forces. On August 21, 1863, Lawrence was attacked by about 400 Confederate guerrillas led by William Quantrill. They burned and looted the town and killed almost 200 townspeople. A detachment of the mounted Company F, 2nd Colorado Volunteer Infantry, pursued and attacked Quantrill's rear guard. (Courtesy of Library of Congress.)

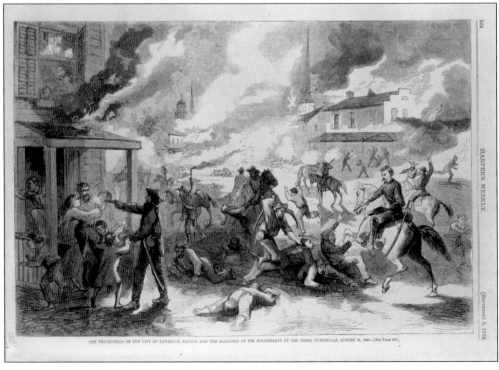

**CONFEDERATE BUSHWHACKER JESSE JAMES.** Before his career as a legendary outlaw, Missourian Jesse James was one of "Bloody Bill" Anderson's Confederate guerrilla band, participating in attacks and atrocities such as the Centralia "massacre" of 22 unarmed Federal troops. Detachments of the 2nd Colorado Volunteer Cavalry were constantly on the move throughout eastern Missouri, attempting to track down bushwhackers such as Jesse and his brother Frank. (Courtesy of Library of Congress)

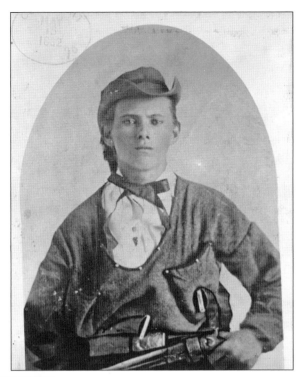

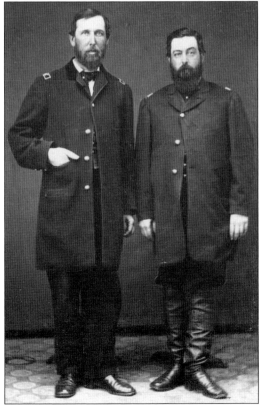

**JAMES FORD AND THEODORE DODD.** Comrades-in-arms since the very beginning of the Civil War, Colonel Ford and Lieutenant Colonel Dodd led the 2nd Colorado Volunteer Cavalry through its most challenging year, 1864. They skillfully spread detachments of the 2nd Colorado throughout eastern Missouri while garrisoning key locations and assembling food and forage to sustain their troops. Their efforts shrank the areas that Confederate guerrillas could use. (Private collection.)

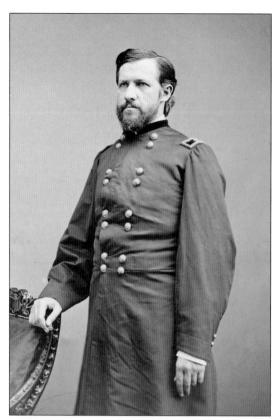

**BRIG. GEN. THOMAS EWING.** In response to Quantrill's raid on Lawrence, Kansas, Brig. Gen. Thomas Ewing announced General Order No. 11 on August 25, 1863, ordering all residents of four counties in eastern Missouri to leave within 15 days and take a loyalty oath. In October, during Price's Raid, Ewing skillfully commanded the outnumbered garrison of Fort Davidson near Pilot Knob, delaying Price's advance and escaping capture. (Courtesy of Library of Congress.)

**BINGHAM'S ORDER NUMBER 11.** Famed artist George Caleb Bingham, though a pro-Union Missourian, painted *Order Number 11*, also known as *Martial Law*, protesting Ewing's evacuation order. This print was adapted from the painting, showing a Missouri family's son lying dead after being killed by Federal troops, and their home being looted. In the background, numerous homes are seen burning. (Courtesy of Library of Congress.)

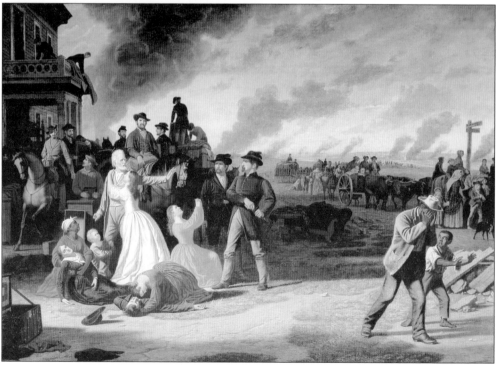

MAJ. GEN. STERLING PRICE. A former Santa Fe Trail merchant, Sterling Price commanded a battalion of Missouri volunteers during the Mexican American War. Joining the Confederate army, "Pap" Price was appointed a major general and led a massive 1864 invasion meant to regain Missouri for the Confederacy. His forces were defeated in several battles in the Kansas City area and forced to retreat to Arkansas. (Courtesy of Library of Congress.)

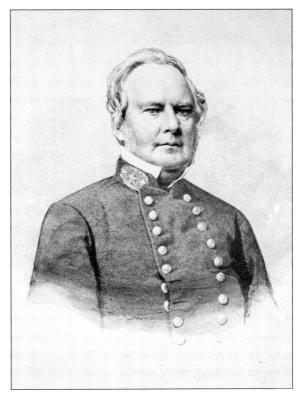

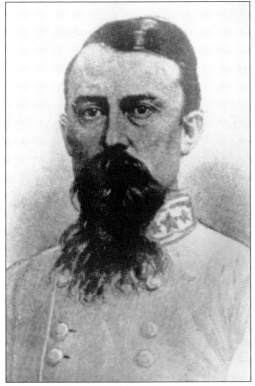

BRIG. GEN. JOSEPH "JO" SHELBY. Shelby fought in the "Bleeding Kansas" conflict on the pro-slavery side. After the Civil War began, he commanded a Confederate cavalry brigade known as the "Iron Brigade" for its battlefield prowess. Shelby led a daring raid into Missouri in 1863, then commanded his brigade during Price's Raid in 1864, fighting against Federal forces including the 2nd Colorado Volunteer Cavalry. (Courtesy of Missouri Historical Society.)

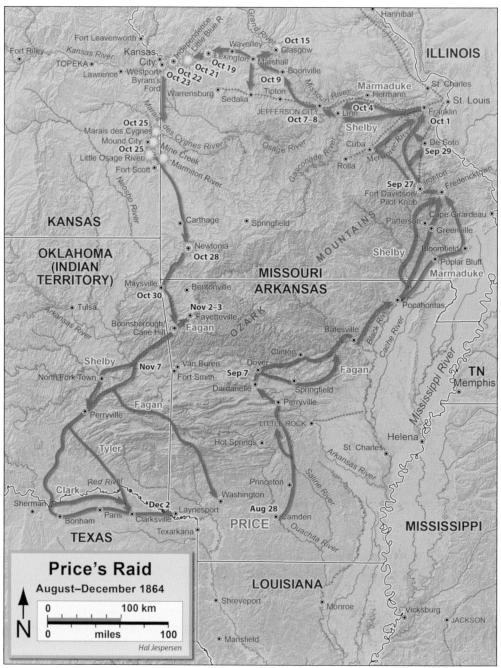

MAP OF PRICE'S RAID. Sterling Price's Confederates advanced across Missouri during the fall of 1864, opposed by smaller Federal forces that slowed their advance. When Price reached the outskirts of Kansas City, Federal troops, including Coloradans, defeated the Confederates, forcing them to retreat to Arkansas. (Map by Hal Jespersen, courtesy of cwmaps.com.)

**MAP OF MISSOURI BATTLES.**
Positions of the troops in four
of the key battles during Price's
Raid—Westport, Charlot, Mine
Creek, and Newtonia—are outlined
in these four maps. This map
series was surveyed and printed
by former Prussian army officer
Albert Koenig, who had firsthand
knowledge of them as a private
in the 2nd Colorado Volunteer
Cavalry. (Courtesy of Library
of Congress.)

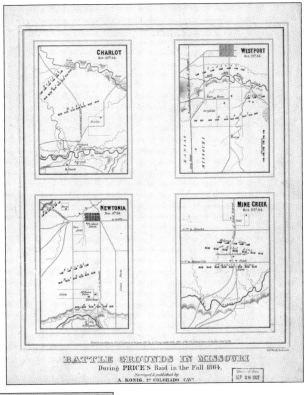

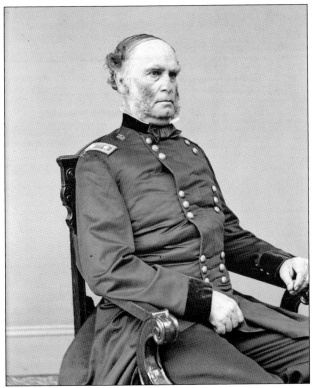

**MAJ. GEN. SAMUEL R. CURTIS.**
West Point graduate Samuel R.
Curtis was appointed a brigadier
general early in the Civil War,
winning victory at the Battle
of Pea Ridge, Arkansas, in
1862. Commanding the Army
of the Border, Curtis repelled
Price's Raid in the Fall of
1864. Gathering Federal forces
including the 2nd Colorado
Volunteer Cavalry and McLain's
Battery, Curtis defeated Price,
pursuing his army to Arkansas.
(Courtesy of Library of Congress.)

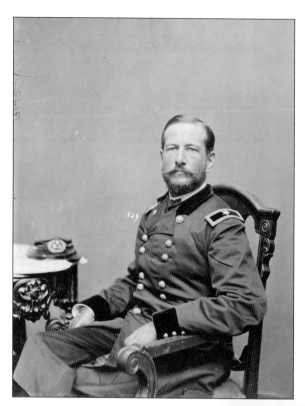

**MAJ. GEN. ALFRED PLEASANTON.** Former commander of the Army of the Potomac cavalry corps, Pleasanton was stationed in Missouri when Price's Raid erupted in the fall of 1864. Commanding 6,600 cavalrymen, Pleasanton attacked Price's rear guard at the Battle of the Big Blue on October 22, as Curtis's forces, including the 2nd Colorado, battled Price frontally. Pleasanton's attacks at Westport and Mine Creek completely shattered Price's army. (Courtesy of Library of Congress.)

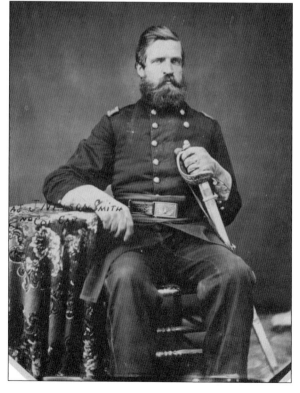

**MAJ. J. NELSON SMITH.** Smith was an outstanding officer, almost worshipped by his men of the 2nd Colorado Volunteer Cavalry. Tall and commanding, he made a conspicuous target on horseback and was killed leading troops at the Battle of the Little Blue on October 20, 1864, by a Confederate sharpshooter. His men killed bushwhacker leader George Todd in revenge. Smith County, Kansas, is named after him. (Private collection.)

**CAPTAIN WEST AND SERGEANT BOYD.**
George West, a newspaper editor from
Golden, Colorado, led Company F, 2nd
Colorado Volunteer Cavalry in a daring
charge on Confederate troops at Camden
Point, Missouri, in 1864. Joseph T. Boyd, a
commissary sergeant in the 2nd Colorado
Volunteer Cavalry, was a Golden resident
like West. He was active in postwar
Republican politics, running unsuccessfully
for US senator in 1876. (Courtesy of History
Colorado 89.451.5025.)

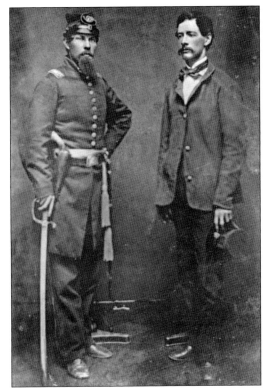

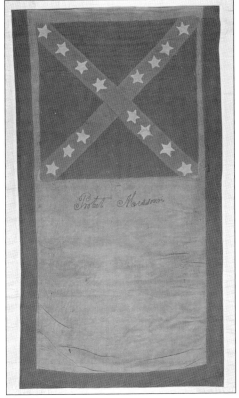

**CAPTURED CONFEDERATE FLAG.** Capt. George
West led a night attack by the 2nd Colorado
against Confederate recruits commanded by
Col. John C. "Coon" Thornton on July 17, 1864.
Cpl. Martin Wilder captured this flag, partly
made from the trousseau of Eliza Kuykendall,
wife of the Confederate adjutant. Preserved
by George West, it was returned to Major
Kuykendall on November 11, 1905, in Denver.
(Courtesy of History Colorado WR.1101.1.)

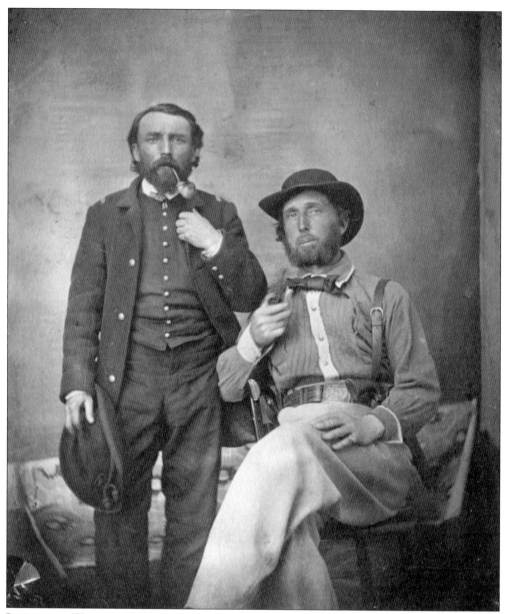

LIEUTENANT WISE AND COLONEL FORD. German-born William "Billy" Wise (left) served in the Denver City Home Guard, later joining the 2nd Colorado Volunteer Infantry, Company D, as first lieutenant. He was described as "an intense rebel hater." Wise was praised by General Blunt for his bravery during Price's Raid in 1864. Here, he and Col. James Ford relax with convivial pipes. (Courtesy of History Colorado Neg. No. F-44010.)

CAPT. EDWARD BERTHOUD. Swiss-born Edward Berthoud served as first lieutenant in the 2nd Colorado Volunteer Infantry and commander of Company D, 2nd Colorado Volunteer Cavalry. His talents were put to better use when Colonel Ford appointed him assistant adjutant general of the Fourth Sub-District of Missouri. Berthoud had an even more distinguished career after the war as an educator, scientist, and legislator. (Courtesy of History Colorado Scan No. 10041097BPF.)

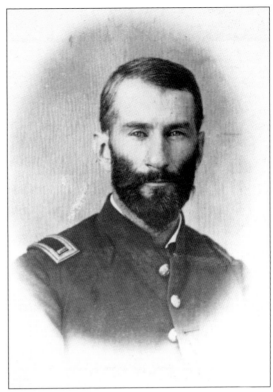

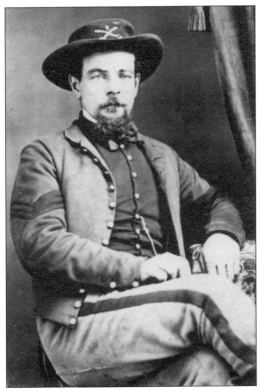

SGT. ANDREW J. PHILLIPS. Phillips was first sergeant of Company F, 2nd Colorado Volunteer Cavalry. The first sergeant's position was described in the 1865 *Customs of Service for Non-Commissioned Officers and Soldiers* as "the foreman: the men are the artisans. He lays out and superintends the details of the work which the captain has directed to be executed." The first sergeant was known as the "Orderly" and oversaw all the administrative details of the company. (Private collection.)

**PVT. OLIVER F. WALLACE.** Wallace served in Company H, 2nd Colorado Volunteer Cavalry. While stationed at Fort Davidson, Missouri, he wrote a presumptuous letter to Maj. Gen. John Schofield begging for his regiment to be sent on more active duty. Schofield responded that Wallace should be put on more strenuous construction duty to absorb his energies. Later, Wallace became editor of the regimental newspaper, the *Soldier's Letter.* (Private collection.)

**SOLDIER'S LETTER NEWSPAPER.** The 2nd Colorado Volunteer Cavalry newspaper was named the *Soldier's Letter.* Fifty issues were printed between August 1864 and November 1865. The editor was Pvt. Oliver Wallace, but there were articles by other authors including soldiers' wives. The paper included three pages of news plus a blank page for soldiers to write a letter before sending the newspaper home. (Courtesy of History Colorado MSS 141.)

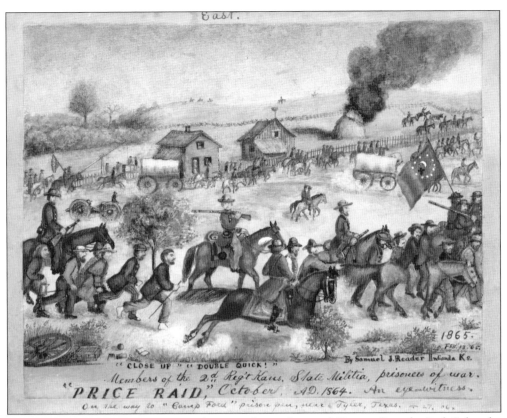

**BATTLE OF THE LITTLE BLUE.** As Price's army advanced toward Kansas City, the 2nd Colorado, McLain's Battery, and other Federal troops fought delaying actions. At the Battle of the Little Blue River on October 21, 1864, the outnumbered Federal forces were outflanked and forced to retreat. Samuel J. Reader, serving with the 2nd Kansas State Militia, was captured, later painting this image of his experience. (Courtesy of Kansas Historical Society.)

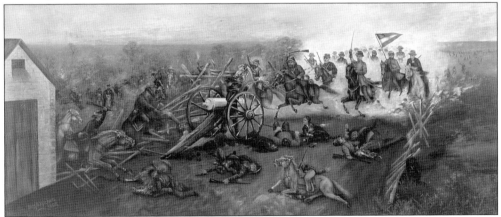

**BATTLE OF THE BIG BLUE.** At the Big Blue River, the 2nd Colorado skirmished with Confederate cavalry on October 22. This was a feint, as the main Confederate forces attacked at Byram's Ford farther south, again outflanking the Federals and forcing them farther back toward Kansas City. Benjamin D. Mileham's painting shows Confederate cavalry attacking Federal lines. The situation was reversed on the following day. (Courtesy of Kansas Historical Society.)

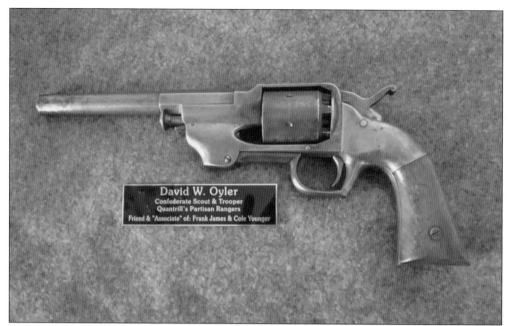

DAVID W. OYLER REVOLVER. This .44 caliber Allen & Wheelock revolver was used by David W. Oyler, one of Quantrill's bushwhackers, during the Civil War, fighting against the 2nd Colorado Volunteer Cavalry. After the war, Oyler's family noted that he was visited by Frank James and Cole Younger, two of his bushwhacker comrades. (Private collection.)

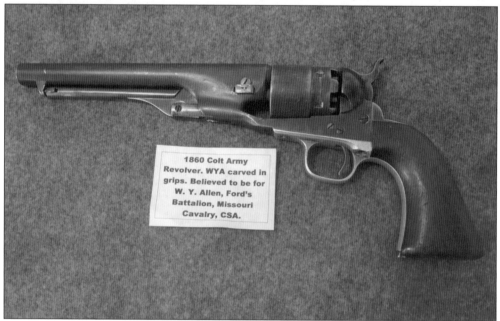

1860 COLT ARMY REVOLVER. The .44 caliber Colt Army revolver was the most heavily used handgun of the Civil War, sturdy and dependable. The US government purchased nearly 130,000 of them, and more than 17,000 of the smaller-caliber Colt Navy revolvers. This example is believed to have been used by W.Y. Allen of Ford's Battalion, Confederate Missouri Cavalry, fighting against the 2nd Colorado Volunteer Cavalry. (Private collection.)

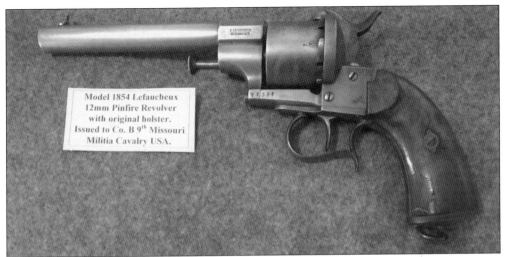

LeFaucheux Pinfire Revolver. Manufactured in France, the 12mm LeFaucheux revolver fired a self-contained cartridge, unlike the usual cap-and-ball ammunition. Both the Union and Confederacy purchased thousands of these technically advanced pistols. This one was issued to Company B, 9th Missouri Militia Cavalry, a unit often working with the 2nd Colorado Volunteer Cavalry to maintain Missouri for the Union. (Private collection.)

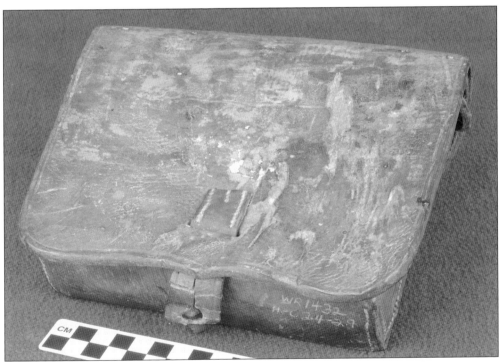

Confederate Cartridge Box. Civil War cartridge boxes held 40 paper cartridges containing gunpowder and a projectile. When taken from the body of a dead Confederate guerrilla near Jefferson City, Missouri, on October 7, 1864, this box was filled with British Enfield .577 caliber cartridges. History Colorado records state that Capt. Edward Berthoud of Company D, 2nd Colorado Volunteer Cavalry, captured this box and donated it. (Courtesy of History Colorado WR.1432.1.)

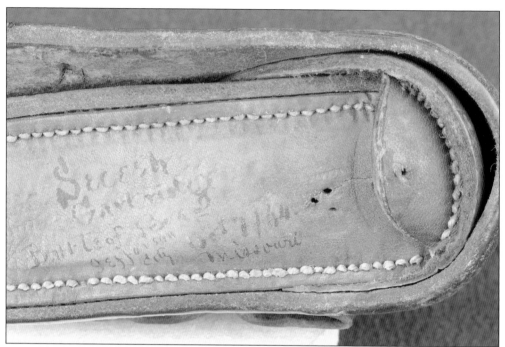

**INSCRIPTION ON CONFEDERATE CARTRIDGE BOX.** Possibly written by Captain Berthoud, the inscription on this box reads, "Secesh Cartridge Battle of Jefferson City Missouri Oct 7 / 64." An illegible word may be "Linn," because there was skirmishing at that town on October 7 when Confederate forces drove Federal troops back into the fortifications surrounding Jefferson City. (Courtesy of History Colorado WR.1432.1.)

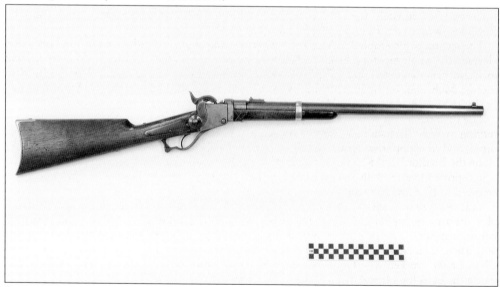

**STARR BREECHLOADING CARBINE.** The .54 caliber Starr carbine was issued to many troopers of the 2nd Colorado Volunteer Cavalry. Though the US Army purchased more than 20,000 of these weapons during the Civil War, soldiers of the 2nd Colorado found them to be "miserably unreliable" and subject to malfunction when even slightly dusty or dirty. (Courtesy of History Colorado WR.6.1.)

# Six

# THE HOME FRONT

The threat of internal subversion and disruption created several "panics" in Colorado Territory during the Civil War. The first happened in October 1861, when it was rumored that 600 men had assembled in a secluded location known as Mace's Hole, southwest of Pueblo, planning to form a Colorado Confederate regiment. Troops of the 4th US Cavalry from Fort Lyon raided Mace's Hole, breaking up the Confederate conclave and capturing 44 prisoners. These men were escorted to Denver City by Company H, the mounted company of the 1st Colorado Volunteer Infantry. Unfortunately, the Confederate prisoners escaped, and two of them—James and John Reynolds—were to return under dire circumstances.

The second panic erupted in May 1863, when a string of grisly murders in the San Luis Valley alarmed the whole territory. Espinosa family members were on the run after fighting troops sent to arrest them for alleged theft. The Espinosas, already wanted men, were blamed for the murders, though doubt about their guilt remains. Vivian Espinosa was killed by a posse and Felipe and Juan Espinosa were caught and killed by scout Tom Tobin and troops from Fort Garland.

The final panic was caused by James and John Reynolds, ordered to return to Colorado while serving in Wells' Battalion, a Texas Confederate unit. The nine to thirteen men were to disrupt supply and transportation routes and recruit additional Confederate guerrillas. Robbing travelers along the Bradford Toll Road near South Park, the Reynolds Gang was pursued by several posses who captured five and killed one of the gang. The five prisoners were executed as they were being escorted to Fort Lyon for trial.

Colorado mining went into a slump during the 1860s, because of the wartime workforce drain, plus the lack of capital and expertise to pursue hard-rock mining. The Colorado population fell dramatically, and the output of gold fell by nearly half. Despite the panics and the mining downturn, Coloradans such as "Auntie" Stone, W.A.H. Loveland, Elizabeth Byers, and "Aunt" Clara Brown worked to establish a solid economic future, support the Colorado troops, and create the basis for a free African American community.

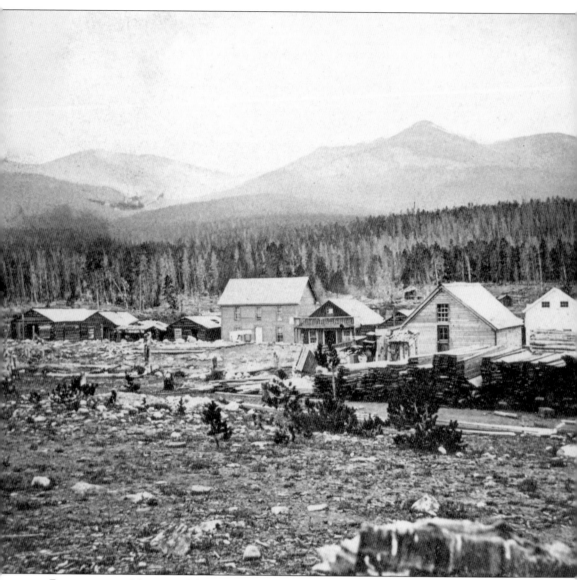

**BRECKENRIDGE, MOUNTAIN MINING CAMP.** Prospectors panning gold from the Blue River founded Breckenridge in November 1859, naming it after miner Thomas Breckenridge. Then they changed the name to Breckinridge after Vice Pres. John C. Breckinridge, hoping to gain a US post office. They succeeded, but when Breckinridge joined the Confederacy, becoming a general in the Confederate army, the residents changed the spelling back. (Courtesy History Colorado Neg. No. F-7835).

COLORADO MINING SLUMP. Because of the lack of investment capital and technical expertise in hard-rock mining, Colorado mining during the Civil War was mostly small-scale placer mining. Even the "Big Hole" dug in Baker's Park in the San Juan Mountains was only five feet deep. The number of men serving in the war also handicapped the industry. (Courtesy of Library of Congress.)

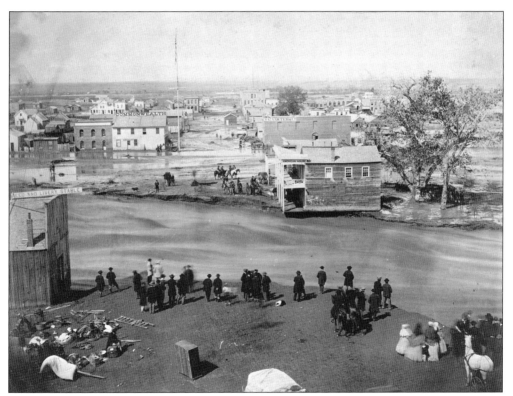

DENVER CITY FLOOD, 1864. Torrential rains caused the waters of Cherry Creek and the Platte River to overflow on May 19, 1864, drowning Denver City under a raging torrent. As the focus of several major trails, Denver City was the military transportation, communications, and supply hub in Colorado Territory during the Civil War. The main Army training and recruitment center, Camp Weld, was also nearby. (Courtesy of Library of Congress.)

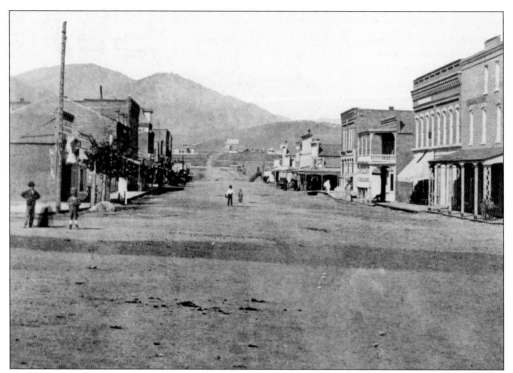

GOLDEN CITY, TERRITORIAL CAPITAL. Golden City, founded in 1859, was central to an area through which four major toll roads led to the mountain gold mining areas. The city became the territorial capital from 1862 to 1867. Though the governor's residence was in Denver City, the territorial legislature often met in Golden City to decide on vital support for Colorado's Federal war efforts. (Courtesy of Golden History Museum 2012.010.038.)

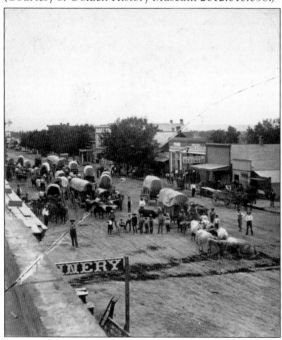

CAÑON CITY, EARLY RECRUITING CENTER. Cañon City was founded in 1860 not in anticipation of gold mining, but in hopes of profiting from local deposits of gypsum, granite, marble, coal, and iron. The new city proved a fertile ground for Federal recruiting since both Ford's and Dodd's Independent Companies enlisted there, providing most of Colorado's volunteers early in the Civil War. (Courtesy of History Colorado 84.192.993.)

**FOUR MILE HOUSE, DENVER.** Four Mile House, built in 1859, was one of the stagecoach stops along the Smoky Hill Trail as it led into Denver City. The Smoky Hill route through central Kansas was a vital military lifeline to Fort Leavenworth during the Civil War. Four Mile House was one of the sustaining links along that route, surviving today as the oldest building in Denver. (Courtesy of History Colorado 93.277.142.)

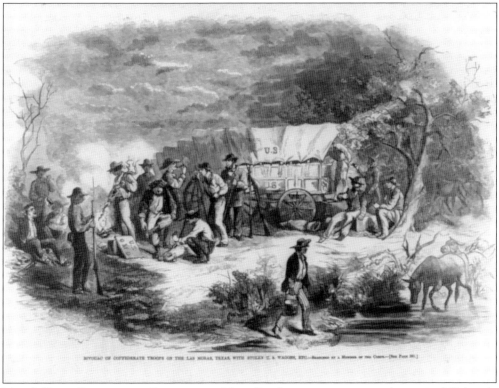

BIVOUAC OF CONFEDERATE TROOPS ON THE LAS MORAS, TEXAS, WITH STOLEN U.S. WAGONS, ETC.—Sketched by a Member of the Corps.—[See Page 891.]

**MACE'S HOLE, CONFEDERATE STRONGHOLD.** Many Southerners were among the original Colorado prospectors during the 1858–1859 Gold Rush. In autumn 1861, they attempted to form a Colorado Confederate regiment of 600 men at Mace's Hole, a remote hideout southwest of Pueblo. Thwarted by Federal troops from Fort Garland, the Confederates scattered into the hills. Their camp possibly resembled this Confederate encampment sketched for *Harper's Weekly*. (Courtesy of Library of Congress.)

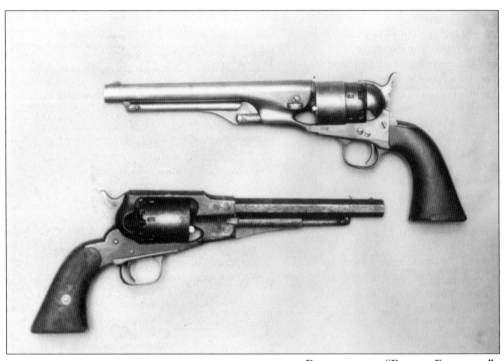

PISTOLS OF THE "BLOODY ESPINOSAS."
A series of brutal murders shocked
Colorado early in 1863. The
murderers were identified as Felipe,
Vivian, and Juan Espinosa. Their
ranches had been looted and burned
by troops attempting to arrest them
for theft. They escaped and as wanted
men were blamed for the murders,
though doubt remains. These are
the pistols they allegedly used in
the murders. (Courtesy of History
Colorado PH. PROP.4843.)

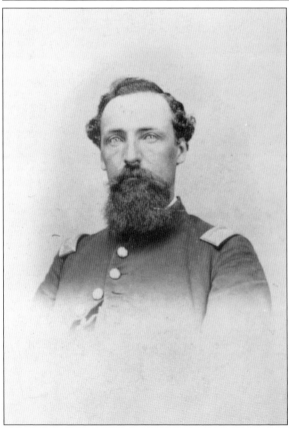

LT. JOHN MCCANNON. A posse led by
John McCannon, a future officer in
the 3rd Colorado Volunteer Cavalry,
found the killers' supposed identity
through an attack survivor. The posse
discovered the Espinosa camp and
fired, killing Vivian Espinosa, and
hacking his head off. Allegedly the
Espinosas went on a murder spree
because of the injustices inflicted
on their family. (Courtesy of History
Colorado Neg. No. F-4681.)

**Tom Tobin, Frontier Scout.** After military and civilian posses failed to find the remaining Espinosas, Col. Samuel Tappan hired veteran hunter and scout Tom Tobin to locate the outlaws. Leading a military detachment from the 1st Colorado Volunteer Cavalry, Tobin located and killed the Espinosas, then cut off their heads and delivered them to Fort Garland. He never received the full reward promised to him. (Courtesy of History Colorado 89.451.3973.)

**Reynolds Gang, Confederate Guerrillas.** James and John Reynolds, former prospectors and founders of Fairplay, were arrested as Confederate sympathizers in 1861 but escaped. They served in a Texas frontier battalion, then led a group of Confederate guerrillas into Colorado Territory in July 1864 to cause chaos, gather loot, and recruit reinforcements. They began by robbing the stagecoach to the town of Buckskin Joe (pictured). (Courtesy of History Colorado SHNH.8301.1.)

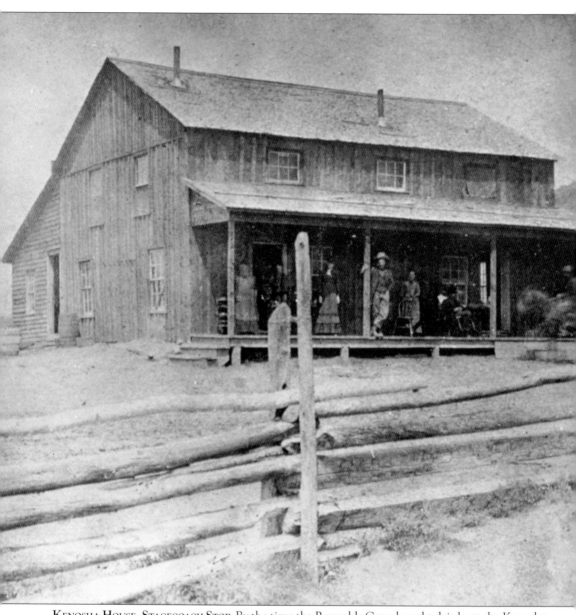

KENOSHA HOUSE, STAGECOACH STOP. By the time the Reynolds Gang bought drinks at the Kenosha House along the Bradford Toll Road, they had robbed numerous travelers. But by September, most of the gang had been captured. While being taken to Fort Lyon for trial, the five captured men were tied to trees and executed by soldiers of the 3rd Colorado Volunteer Cavalry. (Courtesy of History Colorado PH. PROP.3485.)

**"UNCLE DICK" WOOTTON.** Richens Lacey Wootton had a lengthy career as a fur trapper, scout, rancher, and merchant before the Civil War. He established the first general store in Denver City. Born in Virginia, "Uncle Dick" was a Confederate sympathizer, imprisoned briefly in 1861. It was Wootton who found the bullet-riddled bodies of the captured Reynolds Gang members who had been summarily executed. (Courtesy History of Colorado 89.451.4578.)

**FORT COLLINS, 1865.** A military encampment was established in July 1862 along the Cache la Poudre River to guard the Overland Trail. It was named Camp Collins, honoring Col. William O. Collins, commander of the 11th Ohio Volunteer Cavalry and Fort Laramie. The camp flooded out, and a new location was chosen for a more permanent fort, again named after Colonel Collins. (Courtesy of Fort Collins Museum of Discovery H00842.)

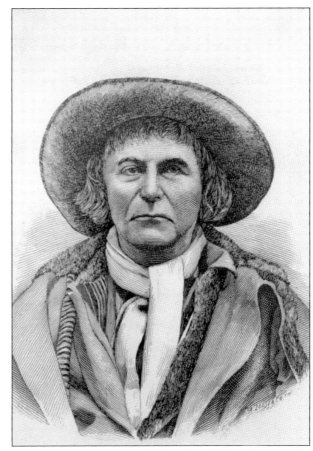

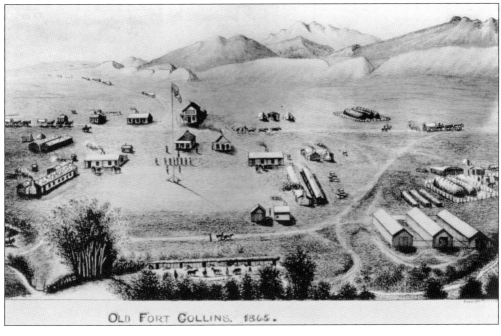

OLD FORT COLLINS, 1865.

HEADQUARTERS BUILDING, FORT COLLINS. Colorado Territory posts such as Fort Collins were vital links in the military communications and transportation chain during the Civil War, even when they saw no action. At times they even served as bases for local law enforcement. Fort Collins was near the junction of the Overland and Cherokee Trails, major corridors through the American West. (Courtesy of Fort Collins Museum of Discovery H11253.)

ELIZABETH "AUNTIE" STONE. Elizabeth Stone and her husband, Judge Lewis Stone, owned a restaurant in Denver City, but the Fort Collins post surgeon, Dr. T.M. Smith, persuaded them to move to the fort and open an officers' mess as part of the civilian support personnel. Elizabeth was dubbed "Auntie" by the fort garrison. Her original cabin survives in Library Park, Fort Collins. (Courtesy of Fort Collins Museum of Discovery H03002.)

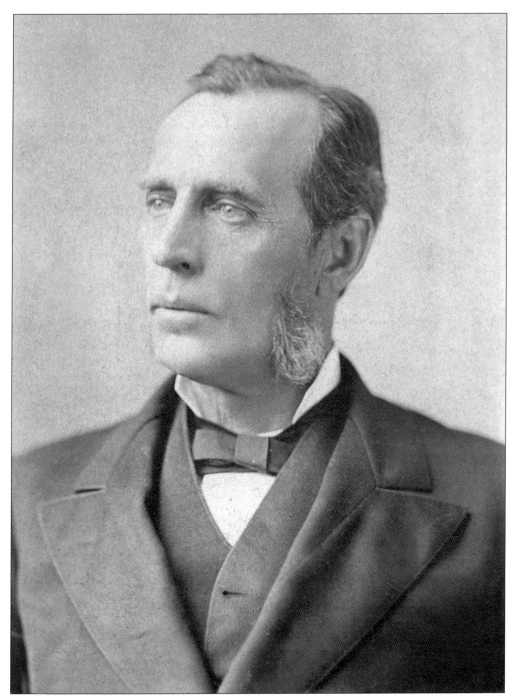

**W.A.H. LOVELAND, ENTREPRENEUR.** During the Civil War, Colorado Territory faced a mining slump and wartime disruption. W.A.H. "Bill" Loveland helped enormously as a Golden City founder and business leader. Loveland's store buildings housed the territorial, county, and city governments. He organized the construction of the Clear Creek Wagon Road to Central City and Black Hawk, and in 1865, the chartering of Colorado's first railroad. (Courtesy of History Colorado 89.451.5452.)

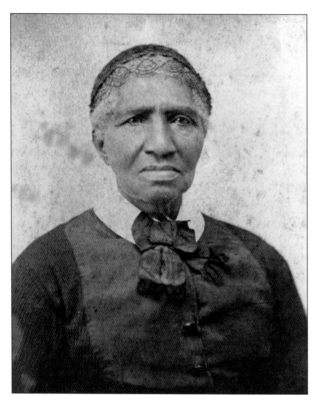

"AUNT" CLARA BROWN, PIONEER BUSINESSWOMAN. Born into slavery, Clara Brown traveled to Colorado Territory in 1859 as a cook for prospectors. In Central City, she worked as a laundress, cook, and midwife, investing in mining and real estate. Her successful businesses supported Central City during the stressful Civil War years. She exemplified the promise of a better life for African Americans in the West. (Courtesy of History Colorado 89.451.1585.)

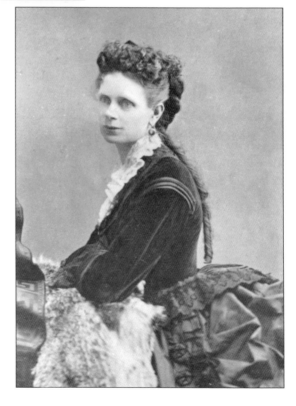

ELIZABETH SUMNER BYERS, COMMUNITY LEADER. In 1859, Elizabeth Byers traveled with her husband, William, and two children to Denver City, where William founded the *Rocky Mountain News*. Elizabeth, a leader in charitable causes, organized the Union Ladies Aid Society in 1860. During the Civil War, the group sewed nightshirts, underwear, and bandages for the Colorado volunteers, and raised money to support them. (Courtesy of History Colorado Neg. No. F-1814.)

# *Seven*

# A FEVER FOR WAR

By the 1860s, the plight of the Plains tribes was increasingly dire. In 1859, veteran fur trader William Bent wrote, "The numerous and warlike Indians . . . are already compressed into a small circle of territory, destitute of food, and itself bisected athwart by the constantly marching lines of emigrants." The large Cheyenne and Arapaho reservation created by the 1851 Treaty of Fort Laramie shrank drastically through the subsequent 1861 Treaty of Fort Wise.

On April 12, 1864, a detachment of the 1st Colorado Volunteer Cavalry clashed with Cheyenne warriors near Fremont's Orchard along the Overland Trail in northeastern Colorado. This dispute over stolen or strayed livestock escalated into other skirmishes, during which Cheyenne encampments were burned and Lean Bear, a Cheyenne chief who had visited Washington in 1863, was killed.

The Cheyenne and their Arapaho and Lakota allies responded with frequent raids on isolated ranches and stagecoach stops. On June 11, the Hungate family was killed and their bodies mutilated, it was assumed, by a Cheyenne or Arapaho war party. The bodies were publicly displayed in Denver, stoking anger and vengeance. The August raids in Nebraska Territory, killing 40-50 white settlers, caused even more alarm and closed the trails across the Plains to Colorado for more than a month.

Territorial governor John Evans first responded on June 27 with a proclamation ordering peaceful Indigenous people to separate from hostile ones and move near military posts. But by August, Evans had petitioned Washington to recruit a 100 days' cavalry regiment and issued a second proclamation authorizing Coloradans to kill any hostile Indigenous people they encountered.

Major "Ned" Wynkoop, commander at Fort Lyon, was approached by several Cheyenne who wished to meet with Evans to discuss peace. This resulted in Wynkoop accompanying seven Cheyenne and Arapaho chiefs to Denver, where on September 28 they met with Evans and Colonel Chivington. The result was inconclusive, and the chiefs were instructed to take their people near Fort Lyon, where they would surrender their weapons and wait for a definitive peace agreement.

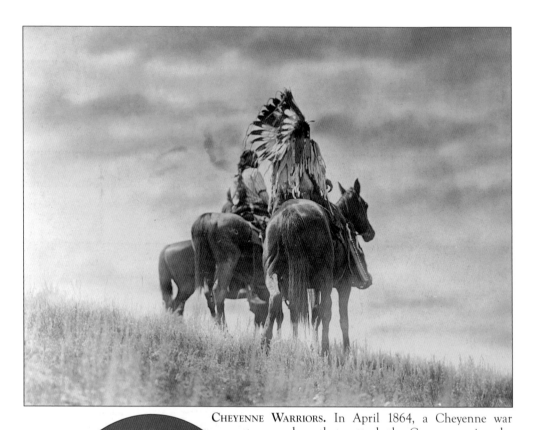

**CHEYENNE WARRIORS.** In April 1864, a Cheyenne war party moved north to attack the Crow, avenging the death of a Northern Cheyenne chief. As they rode through Colorado Territory, they either stole or picked up several stray mules. This led to shots being exchanged with a detachment of the 1st Colorado Volunteer Cavalry near Fremont's Orchard, igniting a war. (Courtesy of Library of Congress.)

**MAJ. JACOB DOWNING.** Jacob Downing joined the 1st Colorado Volunteer Infantry in 1861, leading Coloradans during the New Mexico campaign. In Colorado, his troops attacked a Cheyenne village in April 1864 following the original confrontation at Fremont's Orchard. He called for the "extermination" of the Cheyenne, participated in the Sand Creek Massacre in November 1864, and defended it for the rest of his life. (Courtesy of History Colorado 89.451.5415.)

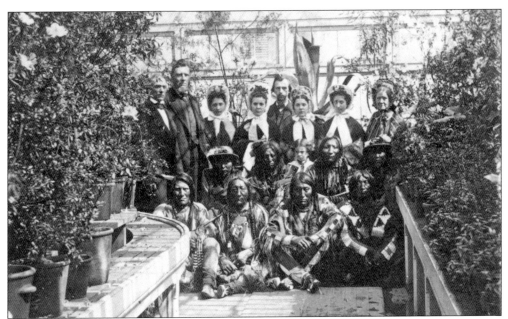

**LEAN BEAR, CHEYENNE CHIEF.** Lean Bear was among these chiefs photographed in the White House Conservatory while visiting President Lincoln in 1863. In May 1864, he advanced from his group of warriors to talk with a detachment of the 1st Colorado Volunteer Cavalry. He and another chief, Star, were shot down by orders of the officer in charge, Lt. George Eayre of McLain's Battery. (Courtesy of Library of Congress.)

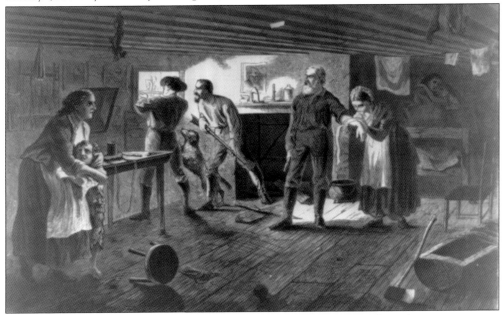

**THE GREAT 1864 RAIDS.** The Cheyenne and Arapaho were joined by the Lakota in numerous raids, many along the Overland Trail following the South Platte River. George Bent wrote, "Into the great valley the war parties of Cheyenne and Sioux broke, attacking and burning the ranches and stage stations, chasing the coaches, running off stock, and forcing the freighters to corral their wagons and fight." (Courtesy of Library of Congress.)

TERRITORIAL GOVERNOR JOHN EVANS. Evans's brilliant career as a promoter of railroad expansion and higher education, plus his dedicated support of the Republican Party, earned him the gubernatorial appointment. Along with Col. John Chivington, he became embroiled in political controversy over Colorado statehood. His reactions to the growing tribal conflict in Colorado led to the Sand Creek Massacre. (Courtesy of Denver Public Library, Western History Department Z-287.)

**WILLIAM BENT, MEDIATOR.** Involved in the fur trade since the 1820s, William Bent was a partner in the influential Bent & St. Vrain trading company. Bent married into the Cheyenne tribe and had several mixed-blood children. He acted as an intermediary, carrying messages for the territorial government to the tribes and negotiating to hopefully prevent hostilities. Four of his children were at the Sand Creek Massacre. (Courtesy of History Colorado 89.451.3350.)

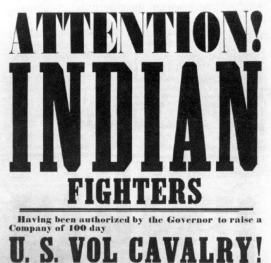

**RECRUITING POSTER, 3RD COLORADO.** The 3rd Colorado Volunteer Cavalry was recruited in response to tribal raids along the Platte-Arkansas Rivers frontier. The US War Department only authorized the unit because of dire predictions of disaster by Governor Evans. As time passed without the regiment seeing any real action, Evans decided it was necessary to use the troops to justify the unit's existence. (Courtesy of History Colorado 96.101.3.)

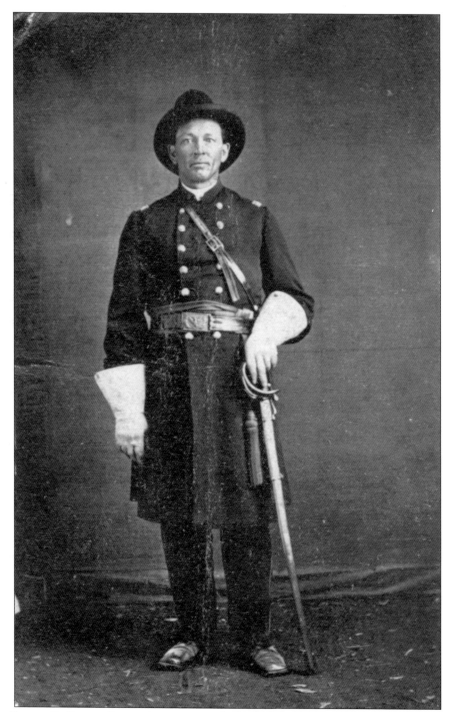

Col. George L. Shoup. During his service with the 2nd Colorado, Shoup proved a daring and effective officer, pursuing Comanche raiders into Texas and later capturing Confederate guerrillas in Colorado. He was appointed colonel of the 3rd Colorado Volunteer Cavalry, leading them at Sand Creek and boasting afterward, "This is the severest chastisement ever given to Indians in battle on the American Continent." (Private collection.)

**3RD COLORADO VOLUNTEER CAVALRY FLAG.** This silk 34-star national flag was made by the women of Denver and presented by them to the 3rd Colorado Volunteer Cavalry on September 26, 1864. After the decommissioning of the 3rd Colorado, the flag was preserved by Capt. Harper Orahood. Later it was donated to the Colorado State Historical Society (now History Colorado) by his family. (Courtesy of History Colorado H.6656.)

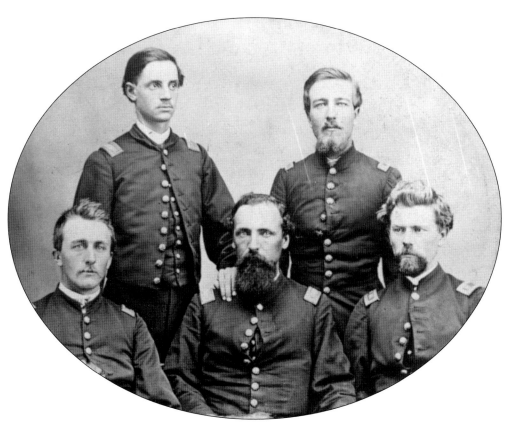

**3RD COLORADO VOLUNTEER CAVALRY OFFICERS.** The 3rd Colorado Volunteer Cavalry was an emergency unit recruited for 100 days of service. Seeing no action for an extended period, it was nicknamed the "Bloodless Third." These officers include, from left to right, (first row) Capt. David H. Nichols, Capt. John McCannon, and Capt. Jay J. Johnson; (second row) Capt. Theodore Cree and unidentified. (Courtesy of History Colorado 89.451.4838.)

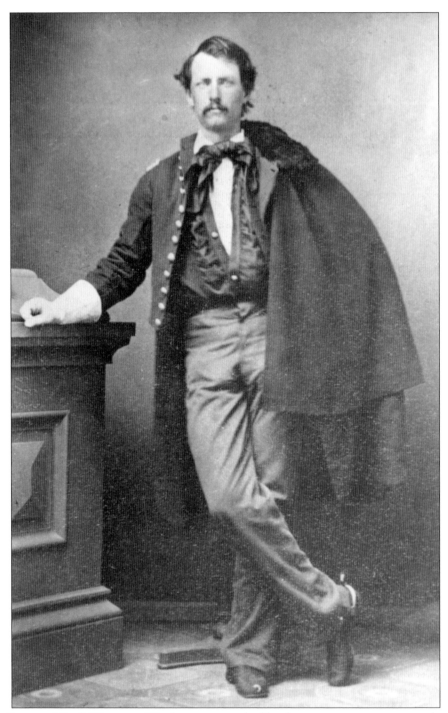

MAJ. EDWARD "NED" WYNKOOP. Wynkoop was touched by the peace overtures presented to him by the Cheyenne while he commanded at Fort Lyon. He traveled to a peace council with the tribes under extremely dangerous circumstances. His attempt to foster a peace agreement failed at Camp Weld, and he was removed from command at Fort Lyon for leaving his post and issuing supplies without permission. (Courtesy of History Colorado 84.84.1.)

CAMP WELD PROCESSION, DENVER CITY. After the Cheyenne and Arapaho chiefs arrived in Denver City, they were provided with carriages and paraded in stately grandeur through the streets leading to Camp Weld. The pomp proved futile, as the conference with Evans and Chivington produced little except the reluctance of either man to agree to any definite peace agreement. (Courtesy of History Colorado 89.451.5437.)

ANOTHER VIEW, CAMP WELD PROCESSION. At the Camp Weld council, Governor Evans questioned the chiefs about various raids, then insisted that they help the military end the war. He then turned them over to Chivington, who demanded that they surrender and lay down their weapons. They were told to return to Fort Lyon and report to Wynkoop when they were ready to do so. (Courtesy of History Colorado 89.451.5438.)

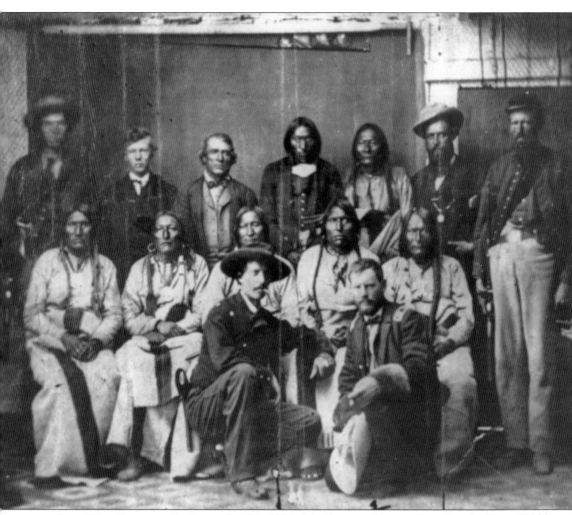

CAMP WELD COUNCIL. On September 28, 1864, this photograph was taken after the Camp Weld Council. The photograph includes, from left to right (first row) Maj. "Ned" Wynkoop and Capt. Silas Soule; (second row, seated) White Antelope, Bull Bear, Black Kettle, Neva, and No-ta-nee; (third row, standing) unidentified, Dexter Colley, John Smith, Heap of Buffalo, Bosse, Samuel Elbert, and unidentified. (Courtesy of History Colorado 89.451.2952.)

## Eight

# TRAGEDY AT SAND CREEK

As darkness fell on November 29, 1864, some 230 Cheyenne and Arapaho people lay dead amid the smoldering remnants of their plundered villages along Sand Creek in southeastern Colorado. Many had been scalped, their fingers severed to take their rings. Body parts had been hacked off for souvenirs. Chief White Antelope's private parts were severed to make a tobacco pouch. Most of the dead were women and children, and many were shot while trying to surrender.

All this resulted from the attack by 675 troops of the 1st and 3rd Colorado Volunteer Cavalry, and the 1st New Mexico Volunteer Infantry, under the overall command of Col. John M. Chivington. Gathering troops in Denver City, Chivington led them through freezing weather to Fort Lyon. There, he divulged his plan to attack the villages along Sand Creek. Officers of the 1st Colorado at the fort protested because they believed the Cheyenne and Arapaho were under their protection. Chivington thundered, "Damn any man who is in sympathy with Indians!" The officers did reluctantly join Chivington's command.

Early the next morning, the troops set out for Sand Creek. After they arrived above the villages, Chivington ordered the troops to open fire. White Antelope ran toward the soldiers to stop the fighting and was killed. Black Kettle raised a large American flag over his lodge. As the troops swarmed the villages, warriors hastily dug rifle pits near the creek bank and fired back, inflicting as many as 52 casualties. Some Cheyenne and Arapaho managed to escape, fleeing to villages on the Smoky Hill River in Kansas.

When the troops returned to Denver City, they paraded through the streets to rapturous applause. The *Rocky Mountain News* trumpeted, "Among the brilliant feats of arms in Indian warfare, the recent campaign of our Colorado volunteers will stand in history with few rivals." Scalps were exhibited in Denver City saloons and theaters. But in his official report, Colonel Chivington foreshadowed future controversy, stating, "The conduct of Captain Silas Soule . . . was at least ill-advised, he saying that he thanked God he killed no Indians."

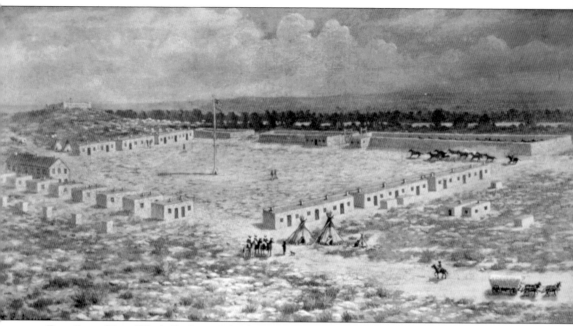

**FORT LYON (FORT WISE).** Built in 1860 close to Bent's New Fort along the Santa Fe Trail, the post was named after the secretary of war, Henry Wise. After Wise joined the Confederacy, it was renamed Fort Lyon after Brig. Gen. Nathaniel Lyon, killed at the Battle of Wilson's Creek in 1861. Fort Lyon was the most important Federal outpost in southern Colorado. (Courtesy of History Colorado Scan No. 10025736.)

**MAJ. SCOTT J. ANTHONY.** Scott Anthony was appointed commanding officer at Fort Lyon in late 1864, replacing Major Wynkoop. When Chivington and the 3rd Colorado arrived unexpectedly on November 28, 1864, Anthony ordered his men to join the attack on the villages. He later regretted the attack, fearing that it would spark a general war with all the Plains tribes. (Courtesy of History Colorado Scan No. 10031855.)

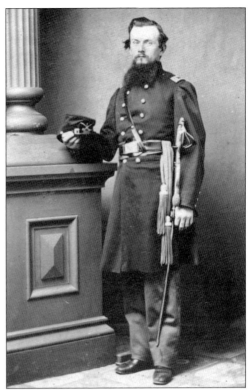

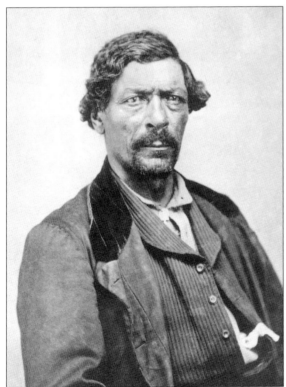

**JIM BECKWOURTH, MOUNTAIN MAN.** Veteran African American fur trapper, trader, and sub-chief of the Crow, Jim Beckwourth was pressed into service as a guide to lead Chivington's troops to the Cheyenne and Arapaho villages on Sand Creek. When the troops reached Fort Lyon, Beckwourth was assisted by Robert Bent along the route to the villages. Beckwourth later testified about the Sand Creek atrocities. (Courtesy of History Colorado 89.451.1762.)

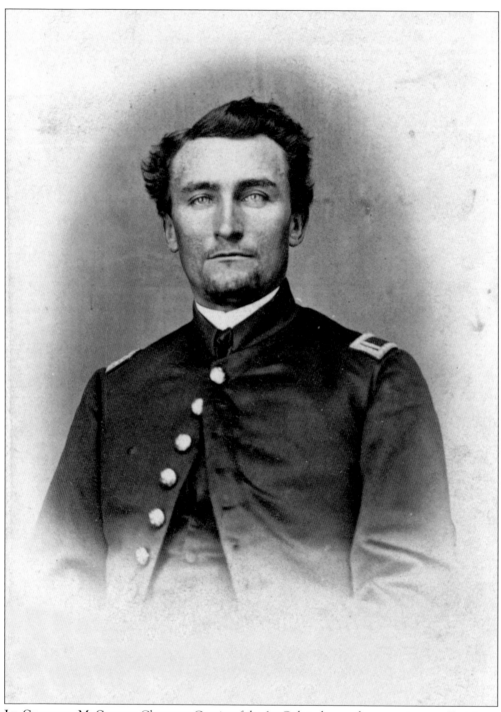

Lt. Chauncey M. Cossitt. Chauncey Cossitt of the 1st Colorado was the commissary at Fort Lyon in 1864. In his office, Col. John M. Chivington outlined his plan for the Sand Creek Massacre to other officers on the evening of November 28, 1864. Cossitt tried to dissuade Chivington, and later gave some of the most damning testimony concerning the massacre to the military inquiry. (Courtesy of History Colorado 95.200.1673.)

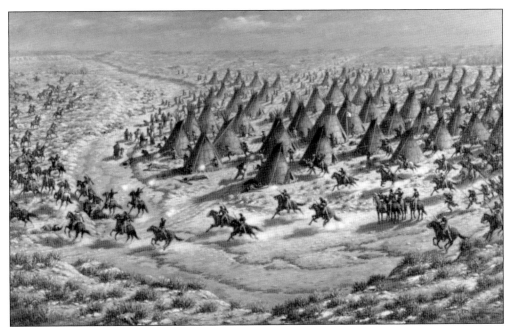

ATTACK AT SAND CREEK. At sunrise on November 29, 1864, about 675 troops commanded by Col. John M. Chivington attacked the Cheyenne and Arapaho villages along Sand Creek. Encircling the villages to secure the pony herds, the troops then poured rifle fire and shells from four mountain howitzers into the tipis. This painting by Robert Lindneux approximates the appearance of the villages. (Courtesy of History Colorado PH. PROP. 1607.)

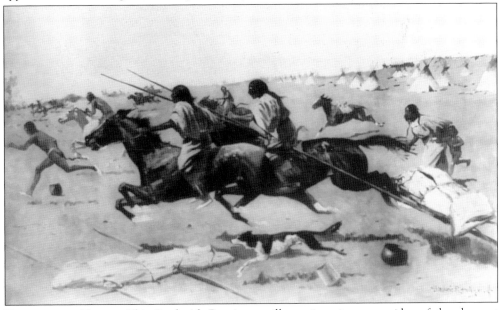

ESCAPING THE TROOPS. This Frederick Remington illustration gives some idea of the chaos at Sand Creek as Cheyenne and Arapaho people tried to escape. They fled for several miles with troops firing at them from different directions. Lt. Joseph Cramer, 1st Colorado, stated that "there seemed to be no organization among our troops, everyone on his own hook and shots flying between our own ranks." (Courtesy of Library of Congress.)

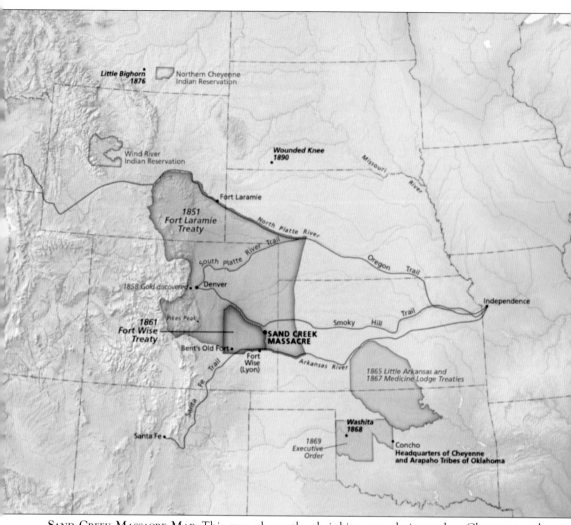

**SAND CREEK MASSACRE MAP.** This map shows the shrinking area designated as Cheyenne and Arapaho land between the Fort Laramie Treaty of 1851 and the 1861 Fort Wise Treaty, as well as the location of the Sand Creek Massacre in southeastern Colorado. (Courtesy of National Park Service.)

**George Bent and Magpie.** George Bent was the son of William Bent and his first wife, Owl Woman. After Joining the Confederate army and fighting in Tennessee and Mississippi, George was captured and paroled. Returning to Colorado, he was living in Black Kettle's camp at Sand Creek when the troops attacked. Shot in the hip, he managed to escape, marrying Black Kettle's niece Magpie in 1866. (Courtesy of History Colorado 84.100.1.)

**Charley Bent, Sand Creek Captive.** Charley Bent was the son of William Bent and his second Cheyenne wife, Yellow Woman. Living in Black Kettle's village when the Sand Creek Massacre occurred, he was captured by Hispanic soldiers or scouts who knew the Bent family, and was spared. Capt. Silas Soule protected Charley and took him to Fort Lyon, where he was later released. (Courtesy of History Colorado 89.451.3285.)

**YELLOW WOLF, CHEYENNE CHIEF.** Yellow Wolf was an influential Cheyenne chief as early as the 1830s, when he advised William Bent about the location of his trading post and fort. This painting of Yellow Wolf by Lt. James Abert dates from 1846. Yellow Wolf, aged 85, was killed at Sand Creek along with his brother Big Man and half of their clan. (Courtesy of Beinecke Library, Yale University.)

**LITTLE ROBE, CHEYENNE CHIEF.**
Renowned warrior Little Robe was
elevated to chiefdom in the early
1860s. In his official report, Colonel
Chivington claimed that Little Robe
was among the chiefs killed at the
Sand Creek Massacre. This was false,
and Little Robe lived another 22
years. He signed the Medicine Lodge
Treaty in 1867, visiting Washington,
DC, several times as a participant
in peace delegations. (Courtesy of
Library of Congress.)

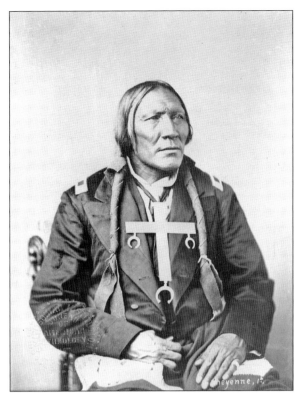

**MAJ. HAL SAYR.** Second major of the 3rd
Colorado Volunteer Cavalry, Hal Sayr
noted the "general dissatisfaction" when
Colonel Chivington took command
during the Sand Creek campaign. At
the Sand Creek Massacre, 1st Colorado
sergeant Lucien Palmer saw Sayr scalp
a dead Cheyenne warrior for the silver
ornaments in his hair and stand by while
his men cut fingers from bodies to get
the rings. (Courtesy of History Colorado
89.451.3285.)

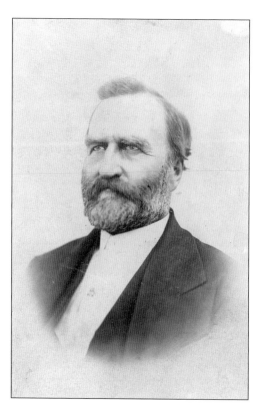

SGT. STEPHEN DECATUR, 3RD COLORADO. Decatur was commissary sergeant of Company C, 3rd Colorado, but was acting battalion adjutant for Lt. Col. Leavitt Bowen at Sand Creek. He testified to counting 450 dead warriors and seeing numerous scalps and bundles of plunder being removed from tipis. He removed the large American flag flown by Black Kettle, presenting it to Lieutenant Colonel Bowen. (Courtesy of Denver Public Library, Western History Collection Z-8819.)

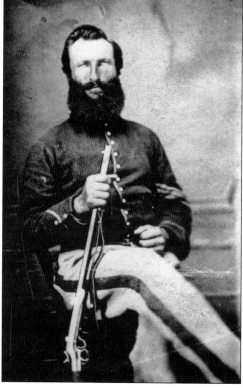

SGT. MORSE COFFIN, 3RD COLORADO. Coffin, here holding his Wesson carbine, opposed killing Cheyenne women and children in an October skirmish. But he explained, defending the Sand Creek Massacre, "The idea was very general that a war of extermination should be waged, that neither sex nor age should be spared . . . and one often heard the expression that 'nits make lice.' " (Courtesy of History Colorado Neg. No. F-4908.)

CAPT. SILAS SOULE. A strong abolitionist, Soule fought against slavery in the "Bleeding Kansas" conflict, then joined the Gold Rush to Colorado. Serving in the 1st Colorado, Soule became sympathetic to the Cheyenne. At Sand Creek, he ordered his men not to fire on the Cheyenne and Arapaho. After testifying in the military inquiry, Soule was shot and killed in Denver shortly after his marriage. (Courtesy of History Colorado 89.451.3340.)

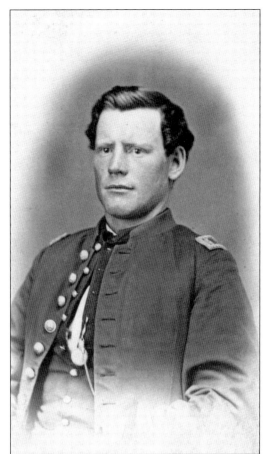

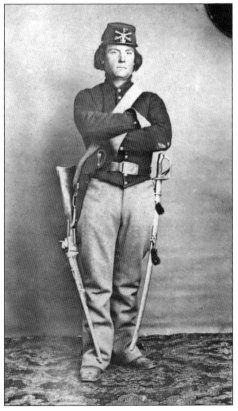

PVT. JOSEPH ALDRICH, 1ST COLORADO. Born in Vermont, Joseph Aldrich served in Company F, 1st Colorado Volunteer Cavalry. His brother Caleb served in the same company. The men of Company F, commanded by Capt. Samuel Cook, were among the first to attack the villages at Sand Creek at daybreak. Aldrich was killed during the fighting as warriors defended their homes. (Courtesy of Denver Public Library, Western History Collection Z-517.)

**"Minnehaha," Sand Creek Survivor.** A 1918 *Alamosa Courier* article states that two Cheyenne girls, two and six years old, were captured at Sand Creek. The younger girl soon died of grief. The older girl, cared for in Central City, was dubbed Minnehaha, a name from *The Song of Hiawatha*. Moving to Boston with the Tappan family, she died of tuberculosis at 16. (Courtesy of Denver Public Library, Western History Collection Z-1513.)

**John D. Howland's Jacket.** John Howland wore this mounted services jacket while serving in Company B, 1st Colorado Volunteer Infantry (later Cavalry). The sergeant's stripes may have been sewn on later since Howland was always listed as a private in company records. In the early 1900s, he sculpted the "On Guard" statue of a Colorado cavalryman formerly placed at the Colorado State Capitol. (Courtesy of History Colorado H.273.1.)

# Nine

# ENDGAME AND REMNANTS

After the Sand Creek Massacre, a military inquiry and two separate Congressional investigations obtained testimony from many who were present. As details of the killing of women and children and mutilation of their bodies were revealed, the attack was condemned by Congress in the strongest terms. Opinion in Colorado Territory was split. Captain Silas Soule, who opposed the attack, was murdered in Denver. Colonel Chivington's officer commission expired so he was never court-martialed, and no civil suit was ever brought against him. Because of his involvement with the Sand Creek Massacre, Governor Evans was forced to resign in 1865.

Col. Thomas Moonlight of the 11th Kansas Volunteer Cavalry replaced Chivington as military commander in Colorado Territory. It was his unenviable job to deal with the catastrophic results of the Sand Creek Massacre. The massacre united the Plains tribes. Their raids increased in ferocity, and Julesburg was burned and sacked twice. As the enlistments of Federal volunteers began to expire, Colorado Territory organized a mounted militia regiment, plus numerous independent companies. Also stationed in Colorado were "Galvanized Yankees," units of former Confederate prisoners who volunteered to fight in the Union Army in the West. The last volunteers of the 1st Colorado Volunteer Cavalry were mustered out in November 1865.

Although the Civil War effectively ended in April–June 1865, hostilities in Colorado Territory did not. The Treaty of the Little Arkansas, signed in October 1865, offered compensation to Sand Creek survivors and dampened some of the violence. At the Medicine Lodge Treaty in 1867, leading Cheyenne, Arapaho, Comanche, Kiowa, and Plains Apache chiefs agreed to move to reservations in the Indian Territory (Oklahoma). But continuing warfare with those who courageously refused to leave their traditional homeland led to conflict at Beecher's Island in 1868 and Summit Springs in 1869.

Today, many reminders of Colorado's Civil War remain. Historic sites at Fort Garland, Fort Larned, Fort Union, Pecos National Monument (including the Glorieta Pass and Apache Canyon battlefields), the original Fort Lyon site, and the Sand Creek National Historic Site testify to the intensity of combat in the West during the American Civil War.

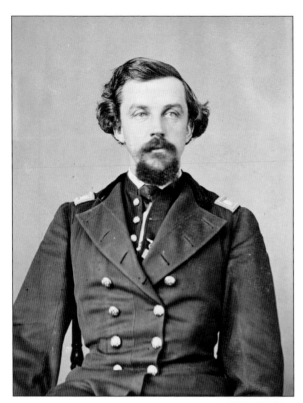

**Lt. Col. Samuel Tappan.** Tappan, an abolitionist, fought to make Kansas a free state before moving to Colorado. Appointed lieutenant colonel of the 1st Colorado, Tappan served during the New Mexico campaign. After Chivington became colonel, he clashed with Tappan, relegating him to command the isolated Fort Garland. Tappan headed the military commission investigating the Sand Creek Massacre. Chivington bitterly contested this, denouncing Tappan as "an avowed enemy." (Courtesy of Library of Congress.)

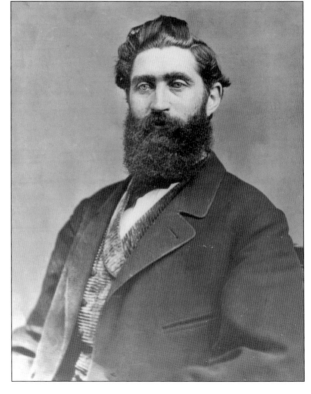

**Col. Thomas Moonlight.** As commander of the 11th Kansas Volunteer Cavalry, Colonel Moonlight previously worked closely with Colorado volunteers in Kansas and Missouri. When he became a military commander in Colorado in 1865, he faced the daunting task of dealing with massive raids by the united tribes. Moonlight fostered the recruitment of a Colorado-mounted militia regiment and several independent companies to cope with the crisis. (Courtesy of Library of Congress.)

**FORT WICKED (GODFREY'S RANCHE).** Located in northeastern Colorado Territory, Holon Godfrey's ranch was a well-known stop along the Overland Trail leading to Denver City, fortified with a high stone wall and watch tower. On January 15–16, 1865, the ranch was attacked by a large war party. With four men present, Godfrey was able to fight off the warriors. He then dubbed his ranch "Fort Wicked." (Courtesy of History Colorado 89.451.5817.)

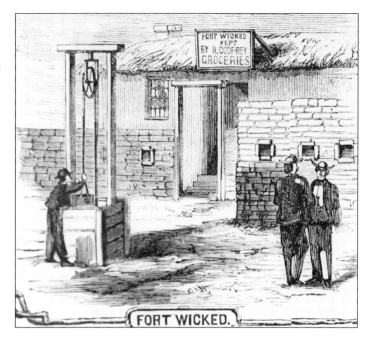

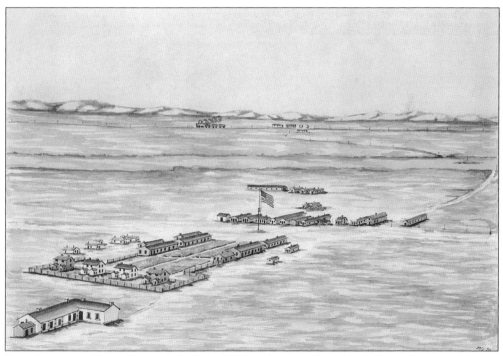

**FORT SEDGWICK (CAMP RANKIN).** Built in 1864 and originally dubbed Camp Rankin, this post guarding the Overland Trail was near the South Platte River and the original Julesburg location. By July 1865, it enclosed four or five sod buildings plus dozens of tents, before being enlarged and renamed Fort Sedgwick after Maj. Gen. John Sedgwick, killed in the Battle of the Wilderness on May 9, 1864. (Courtesy of History Colorado Neg. No. F-1303.)

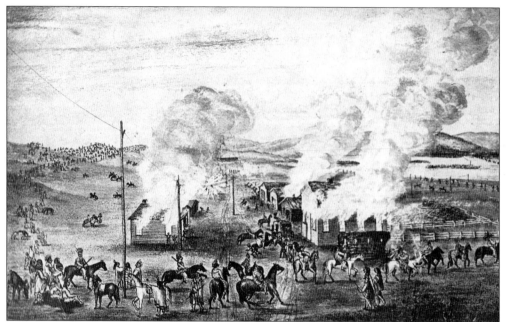

**ATTACKS ON JULESBURG.** On January 6, 1865, the Cheyenne, Arapaho, and Lakota attacked Julesburg on the Overland Trail, 1,000 warriors strong. They lured about 60 soldiers out of Camp Rankin, attacking and killing 15. Then they struck Julesburg with its stagecoach stop, general store, and telegraph office, plundering everything. On February 2, they returned, burning Julesburg. (Courtesy of Denver Public Library, Western History Department X-9613.)

**VIRGINIA DALE STAGECOACH STOP.** As the raids intensified, major Colorado Territory trails were too dangerous to travel. Colonel Moonlight reported that the tribes "burned every ranch between Julesburg and Valley Station." With the South Platte route of the Overland Trail too dangerous, the western loop of the trail became crowded, with more than 50 wagons sometimes stopping overnight at Virginia Dale. (Courtesy of History Colorado PH. PROP.3479.)

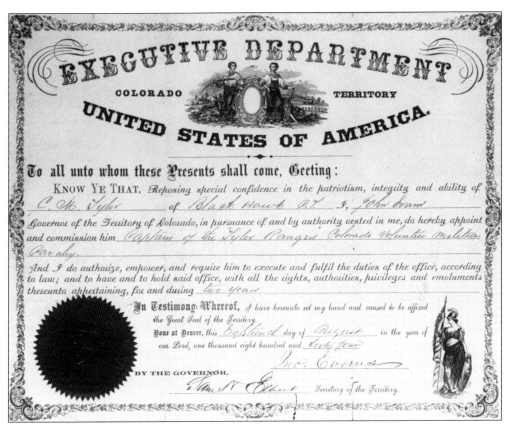

EXECUTIVE DEPARTMENT
COLORADO TERRITORY
UNITED STATES OF AMERICA.

To all unto whom these Presents shall come, Greeting:

KNOW YE THAT, *Reposing special confidence in the patriotism, integrity and ability of* C. M. Tyler *of* Black Hawk C.T. *I,* John Evans *Governor of the Territory of Colorado, in pursuance of and by authority vested in me, do hereby appoint and commission him* Captain of the Tyler Rangers Colorado Volunteer Militia Cavalry.

*And I do authorize, empower, and require him to execute and fulfil the duties of the office, according to law; and to have and to hold said office, with all the rights, authorities, privileges and emoluments thereunto appertaining, for and during* two years

*In Testimony Whereof, I have hereunto set my hand and caused to be affixed the Great Seal of the Territory. Done at Denver, this* Eighteenth *day of* August *in the year of our Lord, one thousand eight hundred and* Sixty four

Jno. Evans

BY THE GOVERNOR.
Saml. N. Elbert Secretary of the Territory.

**TYLER'S RANGERS OFFICER COMMISSION.** This commission issued to Clinton Tyler, signed by territorial governor John Evans, authorized him to assume command of the temporary mounted militia company known as Tyler's Rangers. The company included about 80 men and was one of many short-term militia companies formed in 1865 as the Federal volunteers were being mustered out of the service. (Courtesy of History Colorado MSS 138-2.)

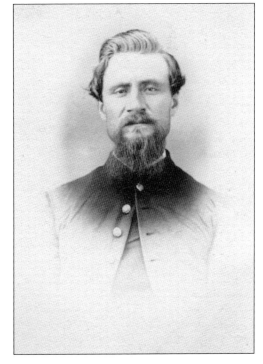

**SECOND LT. MARTIN HENNION.** Lieutenant Hennion and other 2nd Colorado troops were escorting a mule train bringing corn from Fort Leavenworth when they were attacked by warriors east of Fort Larned on June 12, 1865. They were able to fight off the attackers, but the incident illustrated the dangers of traveling the Western trails. Hennion previously survived a deadly attack by Confederate guerrillas in Missouri. (Private collection.)

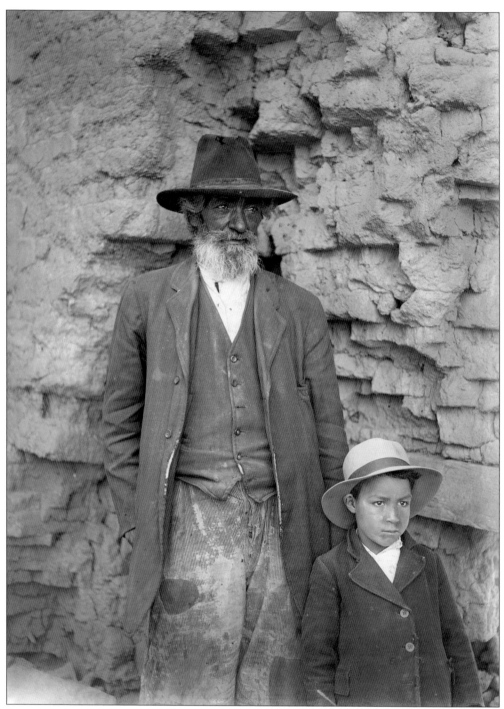

**SAMUEL ADAMS, 1ST COLORADO VETERAN.** Samuel Adams is listed on the rolls of the 1st Colorado Volunteer Cavalry, serving as a cook with Company B, 1864–1865. He was granted a pension as a Civil War veteran. Adams was one of perhaps several dozen African Americans serving with the Colorado troops. This photograph was taken at the Pecos Pueblo ruins in 1915. (Courtesy of Palace of the Governors Photo Archive 013498.)

**TREATY OF THE LITTLE ARKANSAS.** Col. Jesse Leavenworth gathered chiefs of the Plains tribes along the Little Arkansas River in Kansas in October 1865. The resulting treaty offered land and cash to Sand Creek Massacre survivors and their relatives. Amache Prowers (pictured), daughter of Cheyenne chief Ochinee (One Eye), and wife of cattle baron John Wesley Prowers, was one of the land recipients. (Courtesy of History Colorado 89.451.)

**MAJ. URIAH B. HOLLOWAY.** Major Holloway, 2nd Colorado Volunteer Cavalry, mustered out the 530 remaining members of the 2nd Colorado on September 23, 1865, at Fort Leavenworth. They were among the last of the almost 5,000 Federal volunteers from Colorado Territory who served during the Civil War. The 2nd Colorado lost 67 men killed in action and 41 from illness or other causes. (Private collection.)

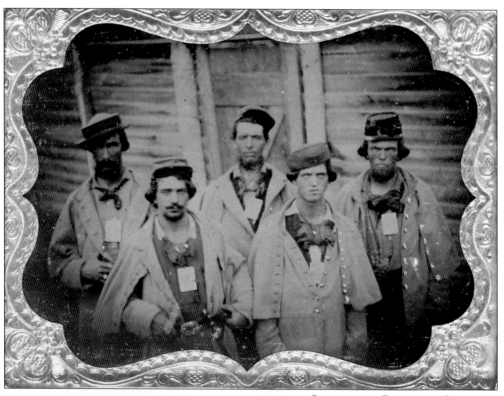

CONFEDERATE PRISONERS, CAMP DOUGLAS, ILLINOIS. In mid-1863, the Federal government, desperate for more troops, began recruiting Confederate prisoners of war, promising they would be sent West and not fight their comrades in the Confederate army. Eventually, six entire regiments—almost 6,000 men—joined up, many of them serving in Colorado Territory. They were dubbed "Galvanized Yankees," proving to be loyal and efficient. (Courtesy of Library of Congress.)

1ST COLORADO VETERANS' REUNION. Surviving men of the Veteran's Battalion, 1st Colorado Volunteer Cavalry pose in front of Denver City Hall sometime in the 1880s or 1890s. The Colorado veterans were intensely proud of their Civil War service, joining the Grand Army of the Republic, the massive Union army veteran's organization. (Courtesy of History Colorado 88.112.1.)

**VETERAN'S BATTALION BANNER.**
This banner, visible in the previous
photograph, is said to have been
made by the women of Denver and
presented to the regiment after the
1862 Battle of Glorieta Pass. The
Veteran's Battalion was not formed
until January 1865, so the banner was
probably made sometime after that. The
"Pet" motto and lamb figure represent
the regiment's nickname, "Gilpin's
Pet Lambs." (Courtesy of History
Colorado HT150.7. A.)

**FORT UNION NATIONAL MONUMENT.** The
first Fort Union was a small complex
of log buildings. The earthen "star
fort," built to withstand Confederate
bombardment, was the second version
of Fort Union. A sprawling adobe
installation became the third Fort
Union after the Civil War. Today,
the Fort Union ruins are managed
by the National Park Service as a
national monument. (Courtesy of
Library of Congress.)

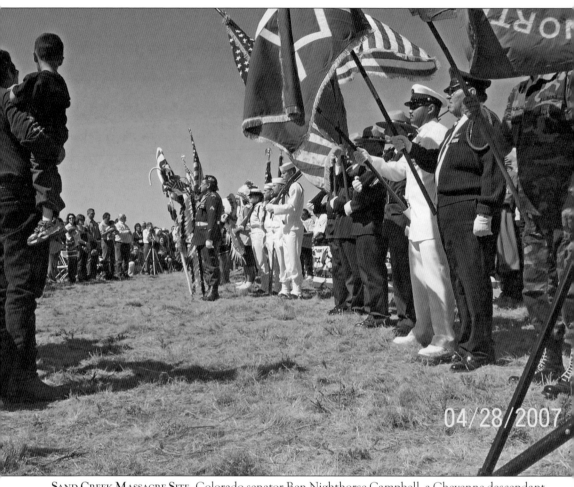

04/28/2007

**SAND CREEK MASSACRE SITE.** Colorado senator Ben Nighthorse Campbell, a Cheyenne descendant of Sand Creek Massacre victims, introduced a 1998 bill to discover the actual Sand Creek Massacre site and establish management options. After extensive evidence was gathered, the Sand Creek Massacre National Historic Site Establishment Act was passed by Congress in 2000. The site opened to the public in 2007 with a stirring ceremony. (Courtesy of National Park Service.)

**FORT GARLAND MUSEUM.** Fort Garland is the only Colorado Civil War fort to survive. Managed by History Colorado, it is a cultural center for the people of the San Luis Valley as well as a military museum. In this photograph, members of Civil War reenactment groups participate in a living history event. (Photograph by Patrick Myers, courtesy of History Colorado.)

**PIGEON'S RANCH, GLORIETA BATTLEFIELD.** The surviving Pigeon's Ranch house along New Mexico State Route 50 is now part of the Pecos National Monument, managed by the National Park Service. The monument includes most of the original Apache Canyon and Glorieta Pass battlefields, as well as the ancient Pecos Pueblo ruins. (Photograph by Kevin Hall.)

FORT LARNED HISTORIC SITE. After decommissioning in 1879, Fort Larned became part of a large ranch. When the National Park Service acquired the site in 1967, almost all buildings were intact, and they have been beautifully renovated. Fort Larned presents a complete picture of an 1800s frontier Army post. Here, members of the 1st Colorado Volunteer Infantry living history group enjoy mail call. (Author.)

CHEYENNE AND ARAPAHO TODAY. The Cheyenne, Arapaho, and other tribes are vitally connected to their ancestral history in Colorado. They advise and collaborate with History Colorado and other organizations to ensure that their tribal history is presented accurately. This photograph shows a Southern Cheyenne dancer during the annual Indian Market and Powwow presented at The Fort restaurant in Morrison, Colorado, by the Tesoro Cultural Center. (Photograph by Dave Holly.)

**SILAS SOULE GRAVE.** After his enlistment ended, Soule was appointed Denver provost marshal. He told a friend that he expected to be killed because of his criticism of the Sand Creek Massacre. Soule married Hersa Coberly on April 1, 1865. On April 23, he was shot to death by Charles Squire, who escaped punishment. Today, his grave in Riverside Cemetery in Denver is always decorated. (Author.)

# BIBLIOGRAPHY

Alberts, Don E. *The Battle of Glorieta: Union Victory in the West.* College Station, TX: Texas A&M University Press, 1998.

————. *Rebels on the Rio Grande: The Civil War Journal of A.B. Peticolas.* Albuquerque, NM: Merit Press, 1993.

Broome, Jeff. *Cheyenne War: Indian Raids on the Roads to Denver, 1864–1869.* Sheridan, CO: Aberdeen Books, 2013.

Brown, Dee. *The Galvanized Yankees.* Lincoln, NE: University of Nebraska Press, 1963.

Hollister, Ovando. *Boldly They Rode: A History of the First Regiment of Volunteers.* Lakewood, CO: Golden Press Publishers, 1949.

Hyde, George, and Savoie Lottinville, ed. *Life of George Bent, Written from His Letters.* Norman, OK: University of Oklahoma Press, 1968.

Josephy Jr., Alvin M. *The Civil War in the American West.* New York, NY: Alfred A. Knopf, 1992.

Mumey, Nolie. *Bloody Trails Along the Rio Grande: A Day-To-Day Diary of Alonzo Ferdinand Ickis.* Denver, CO: Old West Publishing Company, 1958.

Nelson, Megan Kate. *The Three-Cornered War: The Union, The Confederacy, and Native Peoples in the Fight for the West.* New York, NY: Scribner, 2020.

Oliva, Leo. *Fort Larned: Guardian of the Santa Fe Trail.* Topeka, KS: Kansas State Historical Society, 1997.

Pittman, Walter. *Rebels in the Rockies: Confederate Irregulars in the Western Territories.* Jefferson, NC: McFarland & Company, 2014.

Rein, Christopher. *The Second Colorado Cavalry: A Civil War Regiment on the Great Plains.* Norman, OK: University of Oklahoma Press, 2020.

Roberts, Gary. *Massacre at Sand Creek: How Methodists Were Involved in an American Tragedy.* Nashville, TN: Abingdon Press, 2016.

Whitlock, Flint. *Distant Bugles, Distant Drums: The Union Response to the Confederate Invasion of New Mexico.* Boulder, CO: University Press of Colorado, 2006.

Williams, Ellen. *Three Years and a Half in the Army, or History of the Second Colorados.* New York, NY: Fowler & Wells, 1885.

# INDEX

# DISCOVER THOUSANDS OF LOCAL HISTORY BOOKS FEATURING MILLIONS OF VINTAGE IMAGES

Arcadia Publishing, the leading local history publisher in the United States, is committed to making history accessible and meaningful through publishing books that celebrate and preserve the heritage of America's people and places.

Find more books like this at
## www.arcadiapublishing.com

Search for your hometown history, your old stomping grounds, and even your favorite sports team.

Consistent with our mission to preserve history on a local level, this book was printed in South Carolina on American-made paper and manufactured entirely in the United States. Products carrying the accredited Forest Stewardship Council (FSC) label are printed on 100 percent FSC-certified paper.